GREENWICH
IN
50
BUILDINGS

DAVID C. RAMZAN

AMBERLEY

I would like to dedicate this publication to the friends, relations and the people I have known who at some point in their own lives had associations through ancestry or residency with the place of my birth – Greenwich. As for myself, wherever I have lived during the past and wherever I may reside in the future, I will always look upon Greenwich as my home.

First published 2018

Amberley Publishing, The Hill, Stroud
Gloucestershire gl5 4EP

www.amberley-books.com

British Library Cataloguing in Publication Data.
A catalogue record for this book is available from the British Library.

ISBN 978 1 4456 8089 7 (print)
ISBN 978 1 4456 8090 3 (ebook)

Origination by Amberley Publishing.
Printed in Great Britain.

Contents

Introduction

To the north of the ancient thoroughfare of Watling Street, once running across Blackheath and through the corner of Greenwich Park, are the remains of one of Greenwich's earliest permanent buildings, a Romano-Celtic shrine, the foundations laying hidden below the surface of the park. From here the landscape gradually falls away towards the Thames to where a community of Saxons established Greenwich's first major settlement on the river's edge during the seventh century – the title Greenwich an Anglo-Saxon place name. Since these early Saxon times, many notable buildings and structures were erected at the riverside settlement, which evolved into a royal manor and an important place of maritime trade and industry, the town gradually expanding outwards into the fields and woodlands of Kent. Grand palaces and naval and military establishments were erected along the riverfront, and the first royal astronomical observatory was built within the magnificent setting of Greenwich Park, where members of royalty and nobility once hunted deer. Through advancements made in shipbuilding, marine and industrial engineering, Greenwich became a major centre of sea power, trade, commerce and scientific discovery. It was not long before

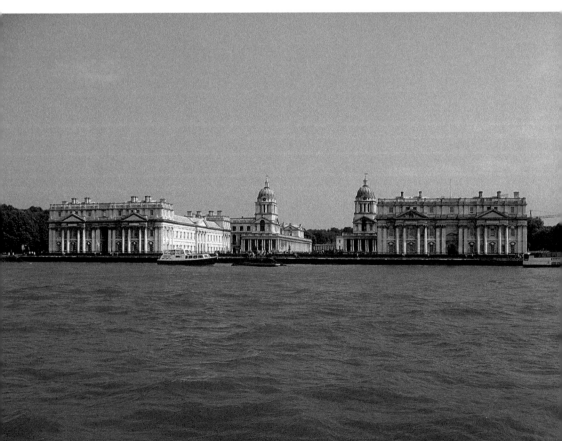

the population of the riverside town grew significantly as new trades and employment opportunities were created. The increase in the working population resulted in the need to build rows and blocks of terraced houses, usually with the addition of a hostelry at the end. Large palatial mansions and spacious detached properties were built in the greener districts of Greenwich, away from the industries spreading outwards from the Thames, to accommodate successful industrialists, wealthy shipowners and prosperous merchants. Places of worship and entertainment were rapidly established for the emerging Greenwich communities, the working-class and upper-class members of society alike. The diversity of Greenwich buildings, the earliest to survive dating to the beginning of the sixteenth century, architecturally represent the town's scientific, artistic and industrial development through the years, its history rewarding Greenwich with World Heritage status in 1997 and recognition as a Royal Borough in 2012.

Within this publication I have selected the most well-known Greenwich buildings, such as the Old Royal Naval College, the Maritime Museum and the Royal Observatory, in addition to several industrial properties, most of which, since built, have gone through a change of use, and a number of less well-known buildings each with an interesting story behind them. As Greenwich continues to experience cultural and commercial change, I have also chosen a number of contemporary buildings to reflect the ever-changing architectural styles of modern, state-of-the-art structures, of which there are many being built throughout the Royal Borough of Greenwich, erected on derelict industrial wastelands or sites of demolished neglected properties. There are also a few buildings of significant historical importance included, which, as I write, are under threat of demolition to make way for even more modern high-rise developments.

> On Thames's bank, in silent thought we stood
> Where Greenwich smiles upon the silver flood;
> Struck with the seat that gave Eliza birth,
> We kneel, and kiss the consecrated earth,
> In pleasing dreams the blissful age renew,
> And call Britannia's glories back to view,
> Behold her cross triumphant on the main,
> The guard of commerce and the dread of Spain.
>
> (*Dr Johnson's London*)

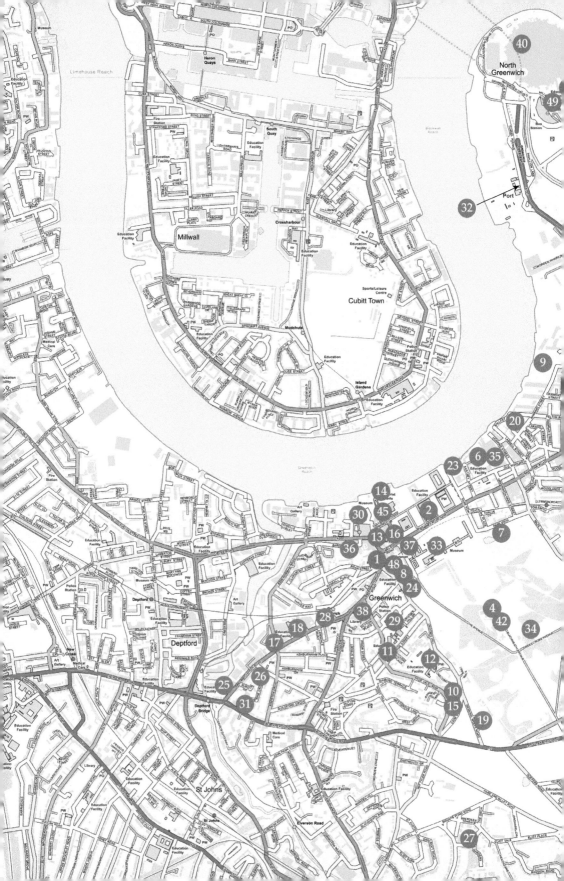

Key

The 50 Buildings

1. St Alfege Church, Greenwich Church Street

The parish church of Greenwich was erected where Alfege, Saxon Archbishop of Canterbury, was killed by pagan Danish raiders after being taken hostage for ransom in 1012 when Greenwich was a Danish stronghold – their longships moored on the Thames close by. The first church, most likely built in wood, was rebuilt during the medieval period and patronage was presented to St Peter's Abbey, Ghent, the manor of Greenwich owned by the Flemish Benedictine order, believed to have been gifted to them by Ethelfleda, daughter of King Alfred the Great. When a majority of the church collapsed during a storm in 1710, the foundations weakened by the many burials to have taken place inside and outside the walls, it was replaced by a new building designed by Nicholas Hawksmoor and constructed in Portland stone. Due to a lack of available funds the surviving medieval tower was refurbished rather than rebuilt to Hawkesmoor's plan, although a spire was added designed to the specification of Greenwich architect John James. The rectangular interior of the church, designed in a classical Grecian style, was famed for its tie-beam

St Alfege Church, Greenwich town centre.

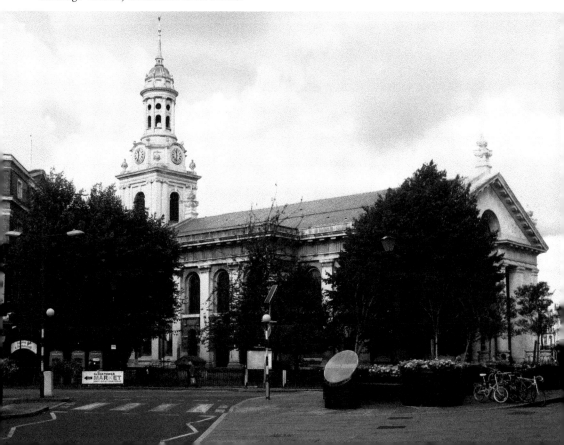

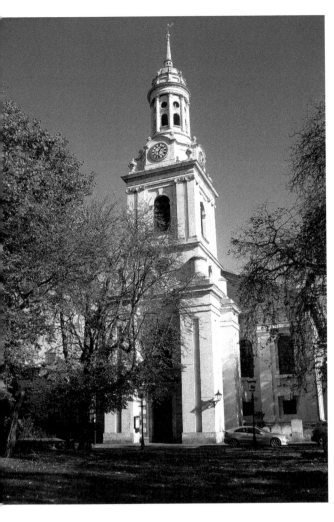

The main church entrance medieval tower.

suspended flat ceiling and giant oval panel, at one time the largest in Europe. Wrought-iron rails on the alter and exquisitely fashioned oak galleries were attributed to an associate of Hawksmoor, Jean Tijou, the main pilasters at the east of the church were painted by artist Sir James Thornhill, responsible for creating the Royal Naval College Painted Hall, and the carvings on the pulpit were credited to Deptford-based Grinling Gibbons. During the Second World War, the roof collapsed after being struck by incendiary bombs and the subsequent blaze gutted much of the church's interior. After hostilities ended restoration of the church was supervised by Professor Richardson RA, the work completed by 1953. Those buried within the church grounds and crypt include several notable Greenwich residents: musical composer and church organist Thomas Tallis, explorer and founder of the Hudson Bay Company Henry Kelsey, Royalist landowner and educational patron John Roan, author and historian William Lambarde, victor at the Battle of Quebec General James Wolfe and celebrated actress of the Georgian period Lavinia Fenton.

2. The Old Royal Naval College, College Way

After restoration of the monarchy in 1660, Charles II commissioned the building of a palace, designed by John Webb, son-in-law of architect Inigo Jones, to replace the dilapidated Palace of Placentia. With only one wing completed, the king's attention turned towards establishing the Royal Observatory and the palace was left unfinished. Following the Glorious Revolution of 1688, when the Catholic James II was deposed in favour of his daughter Mary and her Protestant husband William of Orange, the queen commissioned the building's completion as a hospital for wounded and disabled sailors. Architects Sir Christopher Wren and Nicholas Hawksmoor offered their services free, the building work financed through public fundraising, treasury contributions and smugglers and pirates confiscated booty, with Captain Kidd a major contributor. Completed by Hawksmoor and architect Sir John Vanbrugh after Wren's death, the Royal Hospital incorporated the existing King's Wing and was laid out in four magnificent colonnaded quarters – King Charles Court, King William Court, Queen Anne Court and Queen Mary Court. The first pensioners were admitted to the hospital in 1705. The buildings included pensioners' accommodation, an infirmary, a chapel, brewery, bowling alley and large refectory – the Painted Hall – magnificently decorated with murals painted by Sir James Thornhill in honour of William and Mary. Considered too grand for the residents to have their meals, the Painted Hall became a tourist attraction, the pensioners charging the public a fee for admittance. By the mid-nineteenth century it became financially prudent

George II statue (1735) at the Naval College, Grand Square.

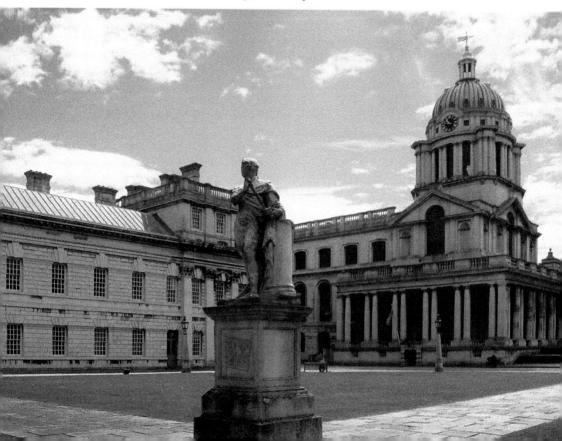

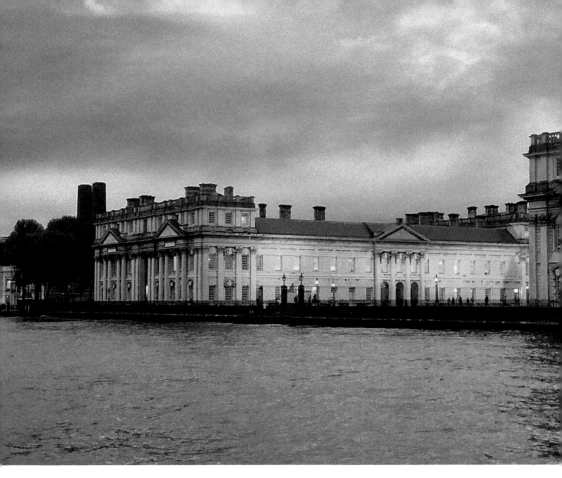

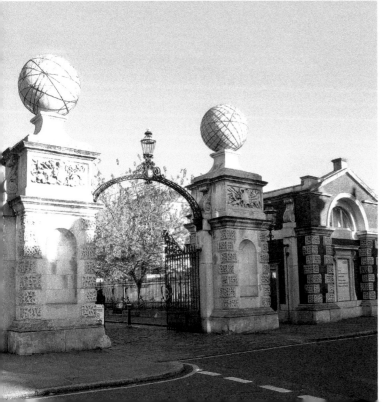

Above: Queen Anne Court and King Charles Court viewed from the Thames.

Left: Old Royal Naval College West Gate with celestial globe adornments.

for hospital residents to receive allowances as out-pensioners, almost 1,000 of 1,400 pensioners electing to leave the hospital, which then closed in 1869. Between 1873 and 1998, the buildings were used as a training centre for Royal Naval officers, approximately 35,000 men and women graduating from the Royal Naval College during the Second World War. In 1959, the Naval Department of Nuclear Science and Technology installed a nuclear reactor named Jason in the King William Quarter, one of the few reactors in the United Kingdom operating in a highly populated area. After the Royal Navy moved out in 1998, the buildings became home to Greenwich University and Trinity Laban Conservatoire of Music and Dance.

3. Charlton House, The Village

When the Jacobean manor was built in 1607, Charlton was just a small hamlet on the edge of a scarp slope east of the Manor of Greenwich. As urbanisation spread outwards from Greenwich, private estates surrounding Charlton House were broken up and the land used to build residential housing. The few remaining open spaces were converted into parklands, and by 1900 Charlton village came under the authority of the Metropolitan Borough of Greenwich. Charlton House is one of the finest examples of Jacobean architecture in England and the only surviving Jacobean mansion in London. Believed to have been designed by one of the country's first professional architects, John Thorpe, clerk of works for the Palace of Placentia, the house was commissioned for the use of Sir Adam Newton, royal tutor to Prince Henry, son of James I. Constructed in red brick with stone

Below left: Charlton House frontage, Charlton village.

Below right: Charlton House main entrance.

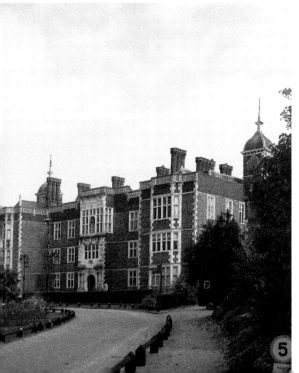
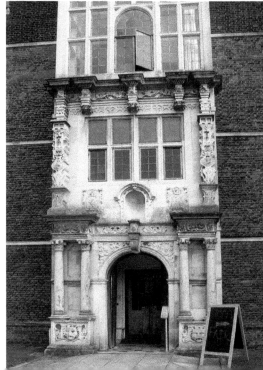

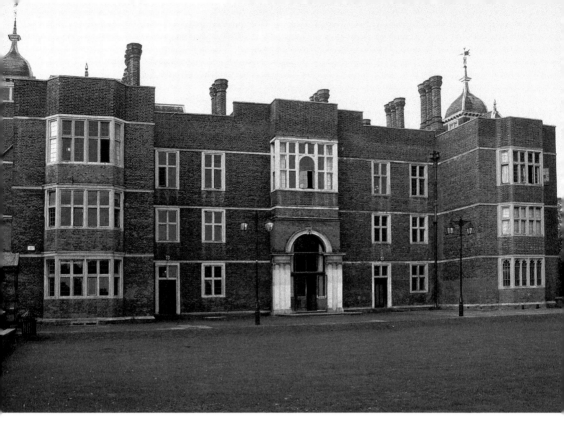

Rear of Charlton House leading onto Charlton Park.

dressing to an E-shape plan, the magnificent interior included a great hall, a dining room with an exquisitely fashioned marble chimney piece, a saloon and a gallery accessed by a carved wooden staircase leading to wood-panelled apartments. The grounds consisted of a courtyard with Cypress trees (thought to be the oldest in England), an orangery attributed to Inigo Jones, and behind this a mulberry tree planted under instruction of James I. The mulberry was one of many grown throughout the country in expectation of creating an English silk industry, the tree's leaves eaten by silkworms to produce raw silk. The king's idealistic venture into silk production failed as the black mulberry had been planted instead of the white, on which silkworms flourished. A series of enclosed formal landscaped pleasure gardens and a kitchen garden were laid out to the rear of the house with a stable block backing onto Charlton Park. The Grade II-listed house was passed down to Newton's son, Royalist Sir Henry Newton, and sold after the Civil War. During the late 1700s, the raucous and rowdy annual Horn Fair was held in the grounds, a festival dating back to the mid-thirteenth century.

4. Royal Observatory, Greenwich Park

Situated within Greenwich Park, built on the site of the disused Greenwich Castle, the Royal Observatory, designed by Sir Christopher Wren, had been commissioned by Charles II who donated £500 and reclaimed material from a Tower of London gatehouse and unused bricks from Tilbury Fort for its construction. The observatory's function, on completion in 1676, was to develop and establish accurate astronomical navigation at sea. At Flamsteed

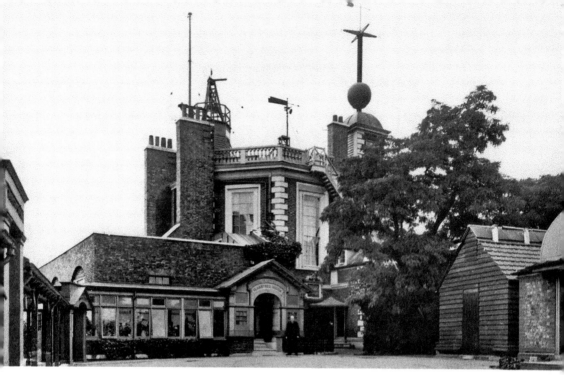

Above: Flamsteed House, Greenwich Park, early 1900s.

Right: Great Equatorial Telescope building to house the UK's largest refracting telescope.

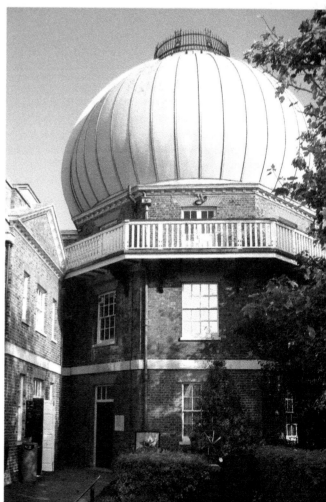

House, the observatory's main building, named after the first astronomer royal, John Flamsteed, a bright red ball was installed on a tower for use as a visual time aid for shipping on the Thames, the ball rising to the top of the mast daily at 12.58 p.m. and dropping at exactly 13.00 hours. Ships navigators then set their time pieces against this signal. In 1884, at the International Meridian Conference held in Washington DC, a delegation voted to make Greenwich the Prime Meridian, Longitude 0°, from where all time zones around the globe were set and measured. Within the grounds of the Royal Observatory, as well as on the east facing outer wall, visitors are able to stand astride a metal strip marking the Meridian Line with one foot in the eastern hemisphere the other in the western hemisphere. A twenty-four-hour clock showing Greenwich Mean Time, built by Charles Shepherd, was installed next to the main gate on the outer boundary observatory wall in 1852, where tourists could then set their own time pieces against. Built between 1891 and 1899, the South Building of the Royal Observatory was used specifically for the study of astrophysics, the large onion-shaped dome housing the Thompson Equatorial telescope. After the Royal Observatory relocated to Herstmonceaux, Sussex in 1957, due to the light pollution in London, the Greenwich buildings were opened as a museum of astronomy, navigation and time keeping; collections of scientific and astronomical equipment include navigational time pieces designed by clockmaker John Harrison. The South Building was later refurbished to hold four galleries of modern astronomy, an education centre and a seminar room.

5. Vanbrugh Castle, Maze Hill

Opposite the eastern gates of Greenwich Park at the top of Maze Hill, a steep roadway leading from Blackheath down to East Greenwich, stands the castellated brick-built Vanbrugh Castle surrounded by a high brick wall. The castle resembles a medieval

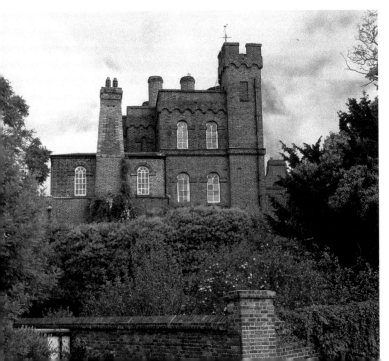

Vanbrugh Castle, Maze Hill.

Blue plaque commemorating Sir John Vanbrugh on the castle's boundary wall.

fortification with battlements and towers, the building's tall narrow windows not unlike lancets (arrowslits) that archers would have fired arrows through in defense of fortifications. Erected between 1717 and 1719 by owner and occupier architect, dramatist and surveyor to the Royal Hospital, Sir John Vanbrugh, the castle was believed to have been modelled upon the French Bastille where Vanbrugh, accused of being a British spy, was imprisoned in 1690. Before known as Vanbrugh Castle the property was referred to as Bastille House. Vanbrugh added several extensions to the castle before his death in 1726, and further additions and alterations were carried out by a succession of owners before the property was donated to the RAF Benevolent Fund in 1920 by the owner, Blackheath-born chemist and oil merchant Alexander Duckham. The castle became a school for the education of the children of RAF personnel killed in service and when the Second World War broke out the students were evacuated to Sussex until hostilities came to an end. It was well known by students that there were hidden tunnels running below the castle, one believed to exit into the woods known as the Dell, close to Maze Hill station. Several enterprising schoolboys discovered a large underground room in the castle basement that they named the Dungeon, the boys gathering there late at night to smoke cigarettes and play music, their tutors unaware these nocturnal activities were taking place. When the school relocated in 1975, the Grade-I listed building returned into private ownership when sold for £100,000. The castle was then refurbished and converted into apartments. In today's current housing market a four-bedroom wing of the castle retails at a modest £2.5 million.

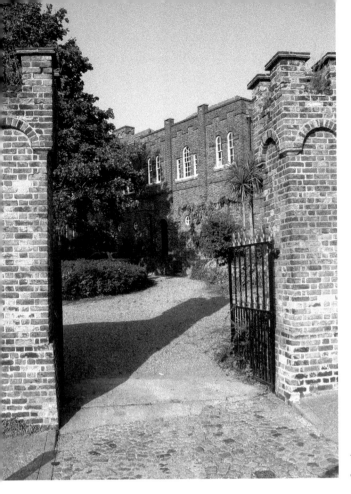

Vanbrugh Castle main gated
entrance on Maze Hill.

6. Trinity Hospital, Highbridge Wharf

Founded in 1613 by English aristocrat the Earl of Northampton, Trinity Hospital
Almshouses, located at Highbridge Wharf between Greenwich Power Station and the
Old Royal Naval College, provided accommodation for twenty-one retired gentlemen of
Greenwich. Erected on the site of Lumley House, once home of Robert Dudley who Elizabeth
I often visited while in residence at the Palace of Placentia, the Grade II-listed hospital,
believed to be the oldest surviving building in the centre of Greenwich, was managed as a
charity by the Mercers' Company. Remodelled in a Gothic style during the early nineteenth
century, a covered passageway below the clock tower leads to a small attractive secluded
cloistered courtyard garden. The hospital's chapel has a splendid sixteenth-century Flemish
window depicting the Crucifixion, believed to have been rescued from a fire that took place
in a property owned by Henry Howard, Earl of Northampton, who purchased Lumley
House in 1609. A monument in memory of the earl erected in Dover Castle's chapel after
his death was later dismantled, when the chapel fell into disrepair, and moved to Trinity
Hospital where it remains today, still in pieces. The garden to the rear of the hospital
includes various species of mature trees, including an old mulberry, one of the many planted
during the reign of James I in expectation of harvesting silk for the proposed English silk
industry. With the Greenwich Meridian passing directly through the Trinity Hospital estate,

Right: Trinity Hospital
Almshouses' former main
Thames-side entrance.

Below: Trinity House,
Highbridge Wharf, late
nineteenth century.

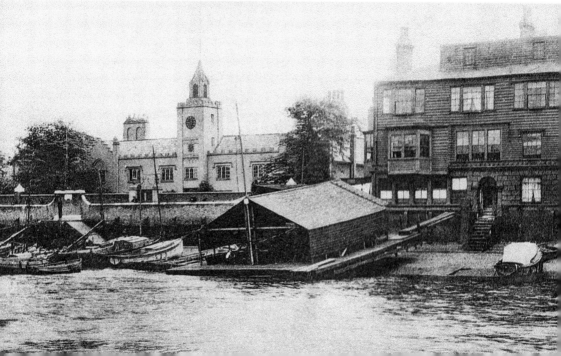

the Mercers' Company commissioned two sundials to be designed and installed when new accommodation blocks were built in 2007 to provide thirty-one flats for retired Greenwich residents, the Latin motto on the sundials taken from Ecclesiastes, Chapter 3, verse 1, 'To everything there is a season, and a time to every purpose under the heaven.'

7. St Alfege Vicarage, Park Vista

The long rambling building stretching from Park Row along Park Vista, once a main Greenwich highway adjacent to Greenwich Park, had been partly erected across the park's old boundary wall. Although a majority of the structure is post-medieval, the property contained a square brick-built red-tiled chamber, believed to predate the Tudor period, which can be seen in a 1720 drawing by Nicholas Hawksmoor. Known as King Henry VII's room, the structure contained a cistern fed with water running through lead pipes from subterranean park conduits to supply the old Palace of Placentia. The building was enlarged by surveyor Joseph Kay for the auditor of Greenwich Hospital, and in 1866 was purchased by the parish of St Alfege for use as the vicarage. Further alterations were made by architect and local resident Samuel Teulon, and between 1965 and 1975 the vicarage was subdivided into four separate residences. Towards the top of a low-roofed building known as the Chantry are the restored arms of Henry VIII, believed to have once been positioned on the cistern tank. On the street façade of the old Rectory an architectural decorative wreath rescued from the demolished Tudor palace can be seen.

St Alfege Vicarage and connecting buildings, Park Vista.

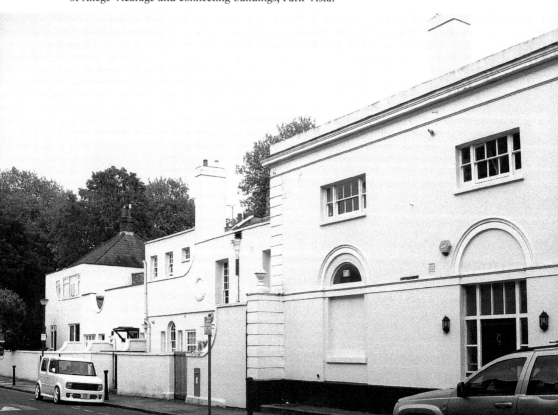

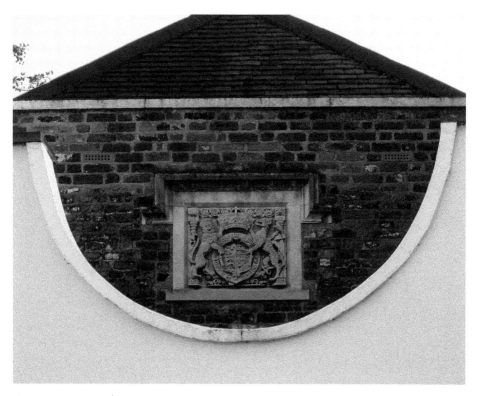

King Henry's coat of arms.

8. Spread Eagle Yard, Nevada Street

A former coaching inn, the Spread Eagle, positioned on the corner of Stockwell Street and Nevada Street since at least the mid-seventeenth century, had once been a busy staging post for horse-drawn carriages travelling down Crooms Hill, a steep winding medieval highway leading from Blackheath towards the town centre. As new methods of travel replaced horse-drawn carriages, coaching inns were no longer required and the Spread Eagle became a general tavern serving alcoholic refreshment to local residents and pensioners of Greenwich Hospital, as well as providing food, drink and accommodation for visitors to the historic town, including actors, musicians and members of Parliament. The stable yard was converted into a grain and malt store, ingredients essential for brewing a plentiful supply of beer. By the early 1900s the Spread Eagle was operating as a printers and book binders up until its purchase by historian and art dealer Dick Moy, one of the founders of the Greenwich Society, in 1964. Moy began restoring the building and although the old inn suffered two fires during renovation work, the Spread Eagle reopened as a stylish restaurant. The art dealer, who ran an antique and art gallery in an adjoining Georgian building, hung many of his artworks, celebrated scenes and landscapes of Greenwich, up on the restaurant walls for the enjoyment of the diners. When the eminent and charismatic Dick Moy died in 2004, the Spread Eagle continued as a restaurant, situated within the ramble of yard buildings, although many of the magnificent works of art collected by Moy

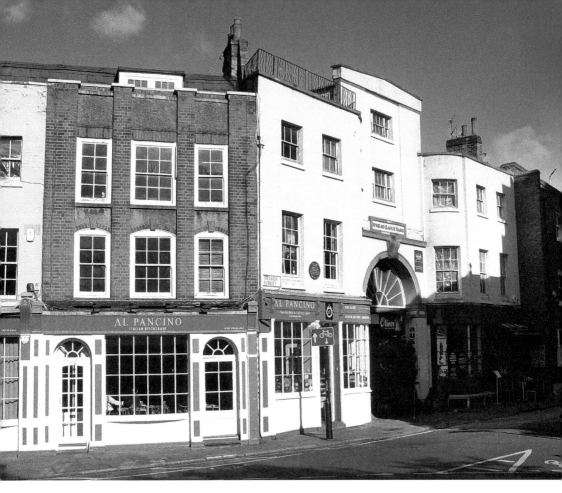

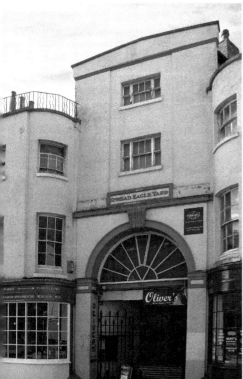

Above: Former Spread Eagle coaching inn buildings, Nevada Street.

Left: Spread Eagle yard entrance.

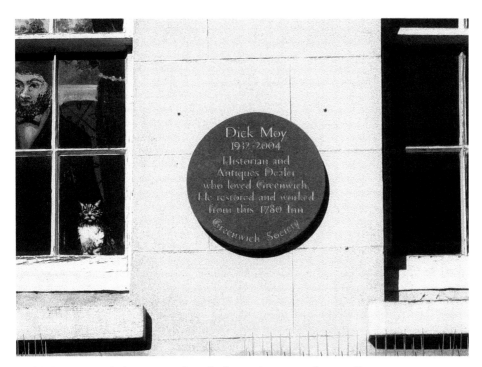

Dick Moy memorial plaque erected on the former inn's outer front wall.

were relocated to the Trafalgar Tavern when both restaurant and tavern were operating under the same management group. The other buildings of Spread Eagle Yard have been occupied by a variety of businesses including a sausage shop, jazz bar, café and patisserie. A plaque dedicated to the memory of Dick Moy can be seen erected up high on a shopfront of this historic group of buildings.

9. Enderby House, Enderby's Wharf

To the west of Greenwich Marsh stands the unimposing, but historically important, Enderby House, a Grade II-listed detached building that will soon be surrounded by newly erected high-rise apartments and leisure properties. The house had been built during the early nineteenth century on a riverside site acquired by Samuel Enderby II for the manufacture of rope and canvas to supply the family's whaling fleet. Although modest in appearance, the Enderby family home was magnificently furnished within, containing a raised cast-iron and glass dome in the ceiling of an octagonal-shaped room with a large eastward facing bay window looking out across the Thames. From the window vessels could be watched moving up and down the river, including Enderby whalers, many mooring off Greenwich Marsh within sight of the house. The Enderby's operated sixty-eight ships, one of which, the *Amelia*, sailed west around Cape Horn in 1789, the first whaler to hunt whales in the Southern Ocean. Although commercial whaling is now a subject of ethical and moral debate, between the early seventeenth century and mid-twentieth century whale hunting was a respected and highly profitable industry. The Enderby's became London's largest

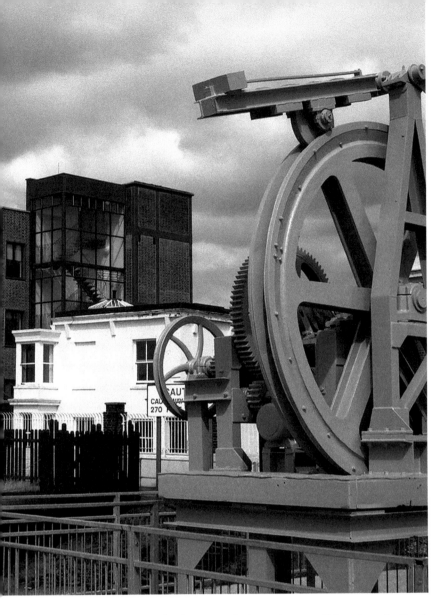

Enderby House, late 1900s, and telegraph cable winding gear, Thames Path.

whaling company funding several pioneering expeditions into the Southern Ocean leading to the discovery of the Bellany Islands and the founding of the Enderby settlement at Port Ross, north-east of the Auckland Islands. After many successful years trading, the money invested in the unproductive Enderby settlement brought about the company's financial ruin and liquidation. The site, along with Enderby House, was sold to Glass, Elliott & Co. for production of submarine telegraph communication cables, including the first cable successfully laid across the seabed of the Atlantic. Glass, Elliott & Co. merged with the Telegraph Construction and Maintenance Co., and when part of the site at Enderby's Wharf was sold for redevelopment, Enderby House, then used as offices, fell into a state of disrepair. Local groups however campaigned to save the celebrated property, which has important links to the historic industries and technological innovations associated with Greenwich Marsh, and are working with developers to ensure Enderby House has a productive and sustainable future.

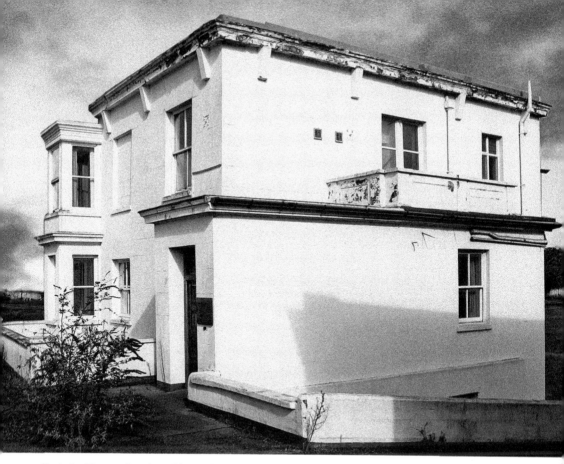

Enderby House after the cable works office closed.

10. Our Ladye Star of the Sea, Crooms Hill

Through Britain's sea trading activities around the globe during the late 1700s, many Catholic seafarers and crewmen of merchant ships from overseas were soon arriving in the maritime town of Greenwich. This was a period when Catholics were still being discriminated against for practising their faith and there was a lack of accepted places for Catholics to worship. At the beginning of the nineteenth century there came a progressive move towards the restoration of Catholicism and when two young brothers, Richard and Joseph North, were saved from drowning in the Thames, their mother vowed to build a church as an offering dedicated to the Catholic faith. Both of her sons went on to become priests. The older brother, Richard, raised the funds on behalf of his mother, with a donation from the Admiralty, to commission the building of Our Ladye Star of the Sea, the word Ladye written as it had been prior to the Reformation. Architect William Wardell and architectural artist and designer Augustus Welby Northmore Pugin, converts from the Church of England and committed to architectural Gothic Revival, were commissioned to design and manage the building of the church. Completed by 1851, the materials used to build the church included Kentish rag, Caen stone and Purbeck marble. The interior, splendidly decorated and richly embellished in the style of early Roman Catholic places of worship, was furnished with works by Pugin and his father Augustus, including magnificent

Left: Our Ladye Star of the Sea, Crooms Hill.

Below: Church interior after completion, mid-1800s.

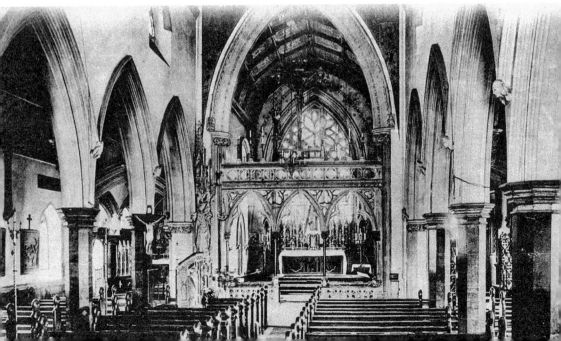

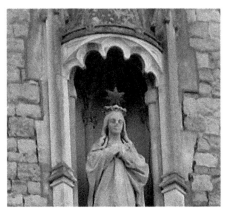

Statue of Mary positioned above the entrance with a star over her head.

stained-glass windows and the tomb chest for Canon Richard North. The congregation was mostly made up from Catholic Irish-born seamen, resident pensioners of the Royal Hospital and visiting Catholic sailors from the Cape Verde Islands, Brazil, India and Portugal.

11. Old Greenwich Dairy, Hyde Vale

The former dairy, a long two-storey brick-built building situated on the corner of Hyde Vale and King George Street, would seem of little historic importance if judged on appearance alone. However, the modestly constructed building, believed to date from the early 1800s, is a rare example of a Georgian commercial workshop located within the West Greenwich Conservation area. Although suffering bomb damage during the Second World War, the interior retains its original timber-framed walls and roof joists. Erected by builder William Smith on land adjacent to his own property, Smith used the building as a workshop while renting space to other small businesses, dressmakers, coppersmiths and a dairyman. George Glover, residing close to the dairy at Little George Street, was listed in census records as a 'Cowkeeper and Dairyman', in all probability using the commercial building as his dairy from where milk and cream would be sold and butter and cheese made to supply the local community. The building, which is still referred to as the Dairy, is facing demolition after developers applied for planning to build houses on the site, and although the destruction of the building has so far been halted, this unique Georgian property is still under threat of being pulled down.

Old Greenwich Dairy buildings, Hyde Vale.

12. The Gazebo, Grange House, Crooms Hill

Opposite Greenwich Park, overlooking Crooms Hill, there is what appears to be a folly, erected for decoration with no practical purpose, the building going largely unnoticed by people passing by. However, the irregular-shaped four-sided building, which has a fascinating history, is a garden gazebo commissioned during the mid-seventeenth century by Grange House owner Sir William Hooker, sheriff and former Lord Mayor of London. Designed by architect Robert Hooke, City of London surveyor after the Great Fire of 1666, the red-brick gazebo, topped by a simple pyramidal tiled roof, forms part of the high boundary wall of Grange House, built in a position to take advantage of the magnificent view across the park. The south-west wall of the gazebo, facing toward the house, had an open round arch containing detached Roman Doric columns and entablatures with a moulded round architrave. To the north-east, the side facing the road, above the window brick pilasters and curved consoles support a cornice and scrolled open pediment with a shield set between wings over a panel dated 1672. The gazebo interior has a splendid moulded ornamental saucer domed plaster ceiling, the surrounds and architrave decorated with plaster leafwork. It is doubtful members of Greenwich's gentry would have enjoyed being entertained at Grange House garden parties, for which the gazebo had been built, as after a visit noted diarist Samuel Pepys wrote 'Sir William kept the poorest mean dirty table in a dirty house of any Sherriff in London'. Grange House, hidden behind high walls and foliage, was formerly known as Paternoster Croft, then Grove House, and later the Grange after being rebuilt around the remains of the original property. Once the residence

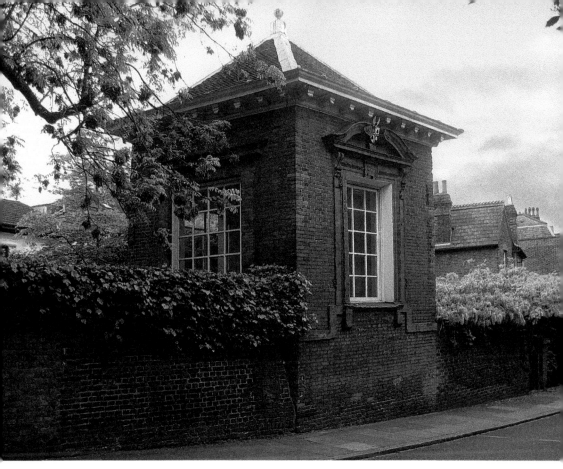

Above: Grange
House gazebo,
Crooms Hill.

Right: Gazebo
pediment crest.

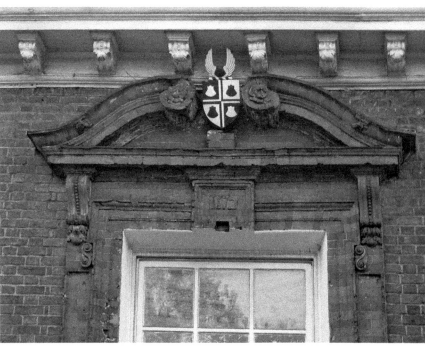

of Edmund Chapmann, chief joiner to Queen Elizabeth I, the house was then occupied by a family of musicians before purchased by Sir William, moving from London to Greenwich to escape the plague. After his death in 1697, Sir William was buried in a vault at St Alfege Church, his white marble monument, surmounted by the figure of the former lord mayor dressed in alderman's robes, erected in the south aisle.

13. Market Slaughterhouse and Stables, Durnford Street

Recently converted into boutique shops, Greenwich Market's slaughterhouse and stables were still in use up until the early 1900s when they were used for storage. Moving from the site of the West Gate of Greenwich Royal Hospital to its present position in the early 1800s, the market, open twice a week (on Wednesdays and Saturdays), traded in livestock and meat, the animals slaughtered on-site at the market's western entrance. Other market traders sold eggs, butter, poultry, fish, fruit and vegetables, while on the market outskirts peddlers offered all types of household goods and wares – glass, china, pots and pans. In earlier times the unregulated slaughter and dressing of animals would have taken place in the open air, these areas becoming known as shambles, many towns and villages having a street or square named after the place of slaughter. In the nineteenth century, concerns over

Former Market Stables.

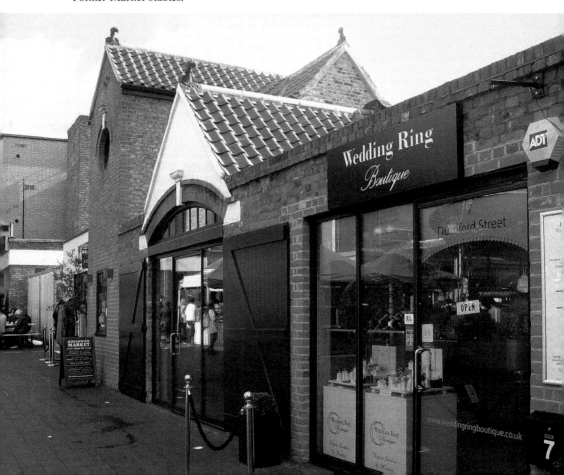

Above left: Slaughterhouse buildings converted into market shops.

Above right: Greenwich Market's own shambles, now a lively street food market.

health and hygiene resulted in the regulation of slaughtering livestock and the installation of purpose-built self-contained slaughterhouses. The buildings were equipped with a water supply and drainage for washing away blood after livestock were killed to reduce the risk of contamination, the slaughter practice stringently officiated. Towards the early 1900s, when there was less demand for livestock slaughter at the market and motorised vehicles became a more efficient means of transporting goods rather than by horse and cart, the slaughterhouse and stables were closed. The rise in the number of high street supermarkets also brought an end to conventional market trading, and after a change in local by-laws allowed the market to open six days a week, by the late 1900s customary Greenwich market fair was replaced by traders selling arts, crafts, antiques and a variety trinkets and collectables. Opposite the slaughterhouse and stables a variety of international cuisine and street food is now served from vibrant colourful market stalls on the site of Greenwich Market's own historic shambles.

14. Greenwich Pier, Cutty Sark Gardens

Throughout the long maritime history of Greenwich, various piers were erected on the river's edge, one of the earliest accommodating boats and ships arriving and departing from the Palace of Placentia. The remains of the Tudor pier can be seen on the Thames foreshore

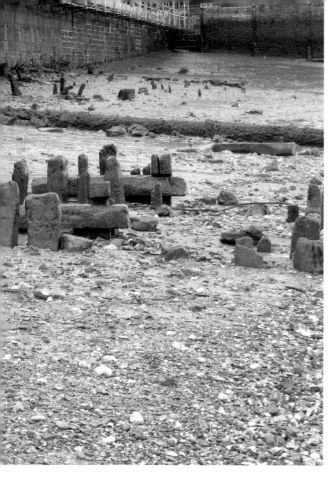

Remains of former Tudor pier, Thames embankment.

after being exposed by the wash of fast modern-day river buses disturbing the sand and mud. Greenwich Pier was erected in 1836, west of the Tudor pier, used mainly by paddle steamers transporting visitors to and from Greenwich. On Whitsuntide 1844, an estimated 20,000 passengers arrived by boat to visit the town's many tourist attractions. As river traffic on the Thames increased, Greenwich Pier became a staging point for boats carrying passengers back and forth between London and the Thames Estuary towns of Essex and Kent, some boats steaming as far as Ramsgate. After the emergence of the London and Kent rail service, riverboat passenger numbers fell into steady decline. In 1876, the five major Thames paddle steamer operators merged their services but the venture failed financially. At the beginning of the twentieth century, London County Council attempted to revive the river passenger services, and although it was forced to close after making huge losses, independent riverboat operators started running pleasure trips taking tourists on excursions back and forth along the Thames from Greenwich Pier. Although improvements and refurbishments had continued to be carried out to the pier since it was first built, in 2007 a major redevelopment took place at an estimated cost of £6 million. The aged but picturesque wooden promenade buildings were demolished and replaced by contemporary pavilions housing a modern central ticket office and three eateries for visitors and tourists. The floating pontoon, from where boats arrive and depart, was renovated and modernised with the addition of new signage, access walkways, automated ticketing and covered waiting areas to keep passengers dry. Although refurbishment took longer than expected, the pier was completed in time for the London 2012 Olympics and Paralympics when Greenwich became a game's venue as well as an important transport link on the Thames.

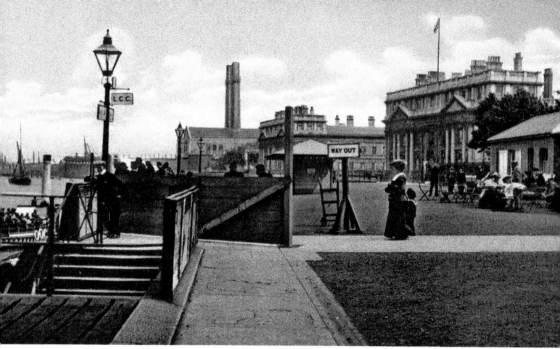

Above: Greenwich
Pier, early 1900s.

Right: New
Greenwich Pier
complex.

15. St Ursuline Convent School, Crooms Hill

After arrival in England, expelled from their convent school by Chancellor Bismarck intent on taking control of all educational institutions in Germany, the Ursuline sisters of Duderstat founded a Catholic school for girls in Greenwich. In 1877, the Roman Catholic order moved into an empty boys' orphanage on Crooms Hill, leased over fifty years for a fee of £80, and within ten years the sisters had purchased an adjacent property, St Mary's Lodge, to expand the school's facilities. When relations with their government improved, the Ursuline Sisters returned to Germany, interchanging with the Ursuline Sisters of Gravelines, the order seeking refuge in England after facing threats from their own government to close all French Catholic convents. Further expansion took place through the purchase of the Georgian mansion Hyde Cliff, adjoining the school gardens. By 1904 the nationalities of students boarding at the school included French, German, Norwegian and English, the school, changing its name to St Ursula's, being officially recognised as a private educational facility. At the outbreak of the Second World War, the sisters and their students were evacuated to Hastings, and then with the threat of invasion on the horizon moved to Brecon in Wales. Although the school roof and the convent suffered some damage when bombs fell over London during the first day of the Blitz on 7 September 1940, the school buildings were repaired and the sisters and students returned at the war's end. The school became voluntary aided in 1949, which brought an end to fee paying and an increase in the number of girls educated at St Ursula's. In the late 1990s the sisters moved accommodation from St Mary's Lodge, their convent for over 100 years, to allow further expansion of the school, relocating to Heathgate and Stobcross, previously the sixth form buildings. St Ursula's is now one of the most well-respected educational establishments in London, the students specialising in humanity studies.

Hyde Cliff, St Ursuline Convent, early 1900s.

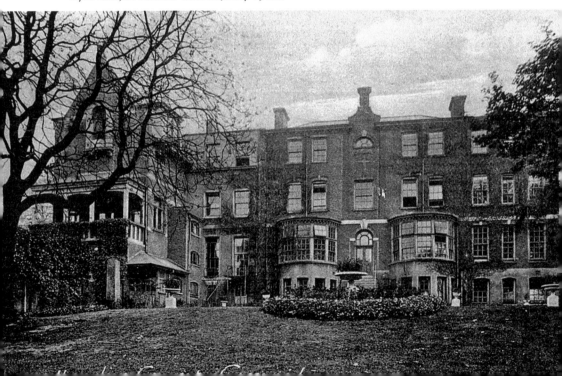

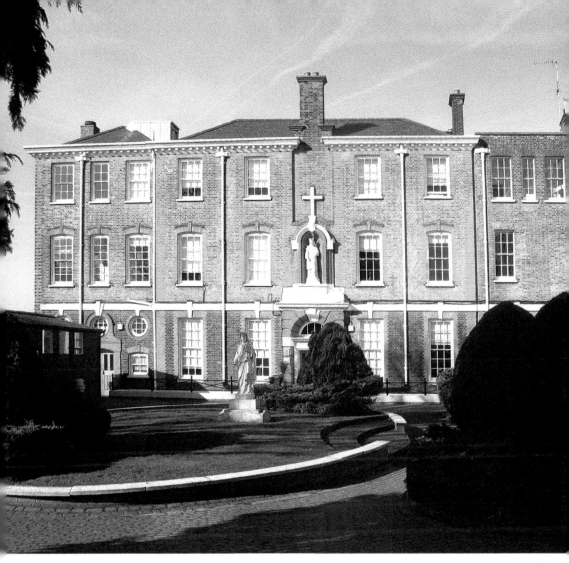

St Ursula's Convent School, Wellington Grove.

16. Greenwich Market, Greenwich Church Street

During the early eighteenth century the parish of Greenwich contained around 1,170 acres of cultivated land, of which 140 acres were arable, 320 acres upland meadows and pasture, and 160 acres made up of market gardeners, a majority of the produce, livestock and crops, sold at Greenwich Market. Cattle and sheep from local pastures, as well as livestock driven in from distant counties, had been sold at the market since the Middle Ages, and a thriving Greenwich fishing industry, sailing out from Billingsgate Dock, west of Greenwich Pier, had supplied fish for sale at market since at least the mid-1300s. The Greenwich fishing industry prospered up until the expansion of freight railways during the late 1800s, when catches of fish arrived by train from northern ports long before Greenwich fishing boats returned from the North Sea. Fish transported by train direct from ports were also much cheaper to buy too; at the time 20 lb of white fish cost just one shilling, an equivalent value

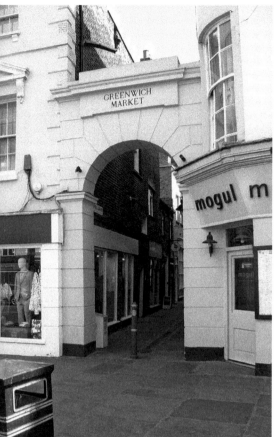

Above left: Market entrance, a former medieval town centre through route, Turnpin Lane.

Above right: Renovated glass roof now covering the once open market square.

of around £20 today. After the Royal Charter Market was assigned to the commissioners of Greenwich Hospital for a 1,000-year lease in December 1700, the market relocated from the grounds of the Royal Hospital to the medieval centre of Greenwich, an area consisting of narrow alleyways, lanes and courtyards where some of the poorest of Greenwich residents lived, and rouges and ruffians could be found lurking around many a street corner. These dilapidated and ramshackle buildings were purchased by the commissioners of the Royal Naval Hospital in 1831 and their surveyor, Joseph Kay, had the medieval properties demolished, only Turnpin Lane to the south retaining the medieval street line. The roads surrounding the market square were transformed into much sort-after elegant residential and commercial properties of Nelson Street, King William Street and Clarence Street, which is now College Approach. After undergoing various stages of renovation work during the early part of the twenty-first century, Greenwich Market has retained its historic character while transformed into one of London's most popular markets offering a variety of traditional and contemporary arts and crafts, antiques and collectables, clothing and food.

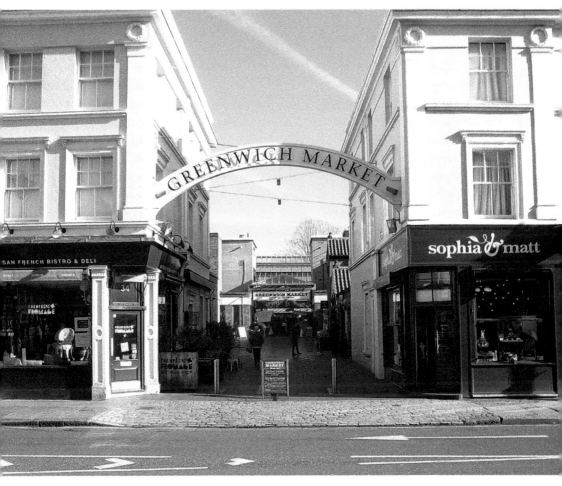

Entrance to Greenwich Market, Greenwich Church Street.

17. Old Greenwich Town Hall, Greenwich High Road

West Greenwich House, erected in 1876, was first used as the District Board of Works headquarters, officially opened by Bromley-born chairman Thomas Norfolk a year later. Employed by one of the largest businesses in the area, Edward Lambert Brewery, Norfolk married into the brewery business when taking Lambert's daughter Edith for his wife. Norfolk later acquired the family's brewery, which became known as Thomas Norfolk & Sons Brewery. Norfolk rose up through the ranks of Greenwich society, which brought him the position of chairman to the District Board of Works. In 1900 the borough council was formed and took over the house for use as the Council Town Hall up until 1939. When a V1 flying bomb landed on a row of houses next to the Town Hall during the Second World War, the explosion caused extensive damage to the building and the domed tower positioned upon the roof parapet. After the war the roof was repaired minus the distinctive dome projection. Renamed West Greenwich House in 1958, the building is now in use as the Greenwich West Community and Arts Centre.

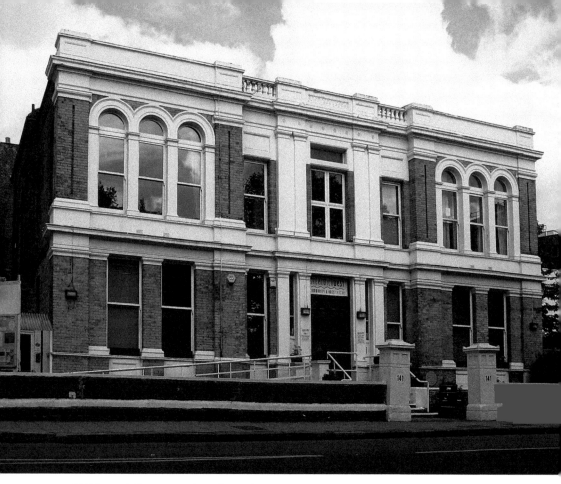

Old Town Hall, Greenwich High Road.

18. Lovibonds Brewery, Greenwich High Road

As Greenwich evolved into an important place of maritime trade and industry during the early nineteenth century, the town's growing population created a need to increase beer production to supply the rising number of public houses and taverns serving alcoholic refreshment to the local workforce and borough's military personnel. Brewing in Greenwich had been a long established tradition since the founding of the Franciscan Friary of Observant Friars in 1485. The Greyfriars, as they became known, were experts in brewing ale that contained various medicinal and antiseptic properties, making its consumption much safer to drink than well water that was often tainted and stale. Although Greenwich had several established breweries during the early 1800s, west county brewer Lovibonds moved to Greenwich in 1847 to take advantage of a rise in demand for beer, purchasing the Nag's Head on Creek Road, then known as Bridge Street, to establish a London-based brewery. Lovibonds built a brand new brewery in 1865 on land purchased from the railway, west of Greenwich Station, the brewery adjacent to the rail-line and the tidal Deptford Creek, rail freight and sailing barges the most popular and economic method of transporting ingredients to brew beer. Lovibonds established several depots across South London to distribute beer by horse and dray and then by motorised vehicles to public

Above: Former Lovibonds Brewery buildings, Greenwich High Road.

Below: Brewery damage caused by falling doodlebug.

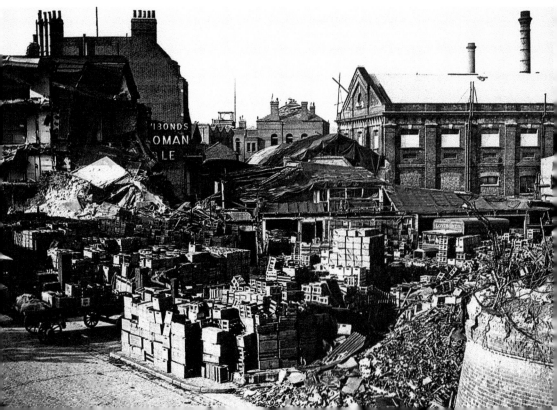

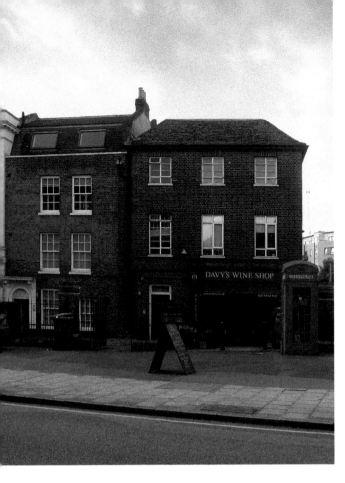

Davy's wine shop.

houses, off licences and hotels. The brewery building suffered damage from a doodlebug explosion in 1944, which halted beer production for a short period; however, the building was soon repaired and South East Londoner's continued to be supplied with Lovibonds beer throughout the remainder of the war. Lovibonds ceased brewing in 1959 turning its business interests towards the wine trade. The brewery site at Greenwich was purchased by John Davy & Co in 1968, a London wine merchant established in 1870, and after refurbishment the brewery buildings were used as a wine vault, offices, shop, restaurant and bar. Today, visitors to the historic brewery are able to take a glass or two of fine wine in the bar or purchase a vintage bottle from the shop at one of London's most well-established wine merchants.

19. The Ranger's House, Chesterfield Walk

To the western edge of Greenwich Park stands an impressive red-brick Georgian villa, built in 1699 for Royal Naval seafarer Admiral Francis Hosier, who made his fortune through trading ventures at sea. After the admiral's death, the lease was inherited by the 4th Earl of Chesterfield, after which the property was renamed Chesterfield House. The earl made improvements to the house including the addition of a bow windowed gallery for entertaining his guests. The house was sold in 1782 to Edward Hulse, High Sheriff of Kent and Deputy Governor of the Hudson's Bay Co. With Hulse having no heirs to pass

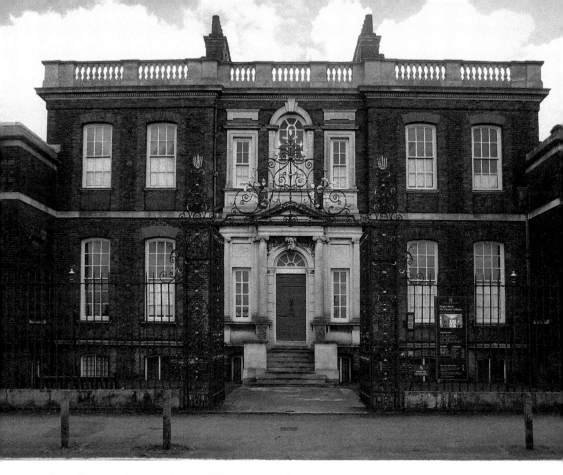

Above: Ranger's House main entrance, Chesterfield Walk.

Right: Rear of the Ranger's House overlooking Greenwich Park Rose Garden.

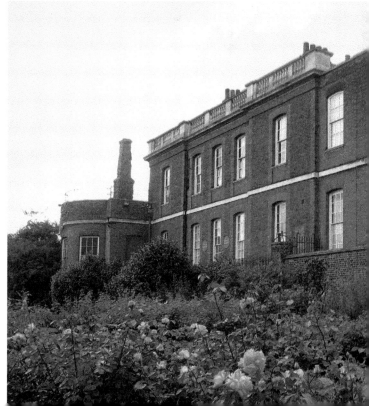

the house onto when he died, the property became a grace and favour residence granted to members of the royal household by the reigning monarch. For a short period the house was occupied by the estranged wife of George III, Caroline of Brunswick, who allegedly had a number of liaisons and affairs with various lovers at the adjacent Montague House. When the Georgian villa became the official residence of the ranger of Greenwich Park by royal appointment, a position holding few official responsibilities, the property was named the Ranger's House. The last ranger to hold the position was Field Marshal Garnet Joseph Wolsley, Commander in Chief of the Forces, who left the post in 1896. Acquired by London County Council in the late 1800s, the Ranger's House served as a sports and social club before coming into the care of English Heritage for exhibiting traditional and contemporary art. In 2002, the Ranger's House became home to the Wernher Collection, works of art, silver, jewels, bronzes and porcelain assembled by German-born diamond mine entrepreneur Sir Julius Wernher, a respected member of the British establishment and one of the richest men in the United Kingdom.

20. Harbour Master's House, Ballast Quay

At the east end of a row of houses at the junction of Ballast Quay and Pelton Road, erected on the site of former fisherman's dwelling, Thames Cottage, stands the nineteenth century detached Harbour Master's Office built by local architect George Smith. The Grade II-listed building was thought to have been first occupied by local harbour master Charles

Harbour Master's Office, Ballast Quay, early 1900s.

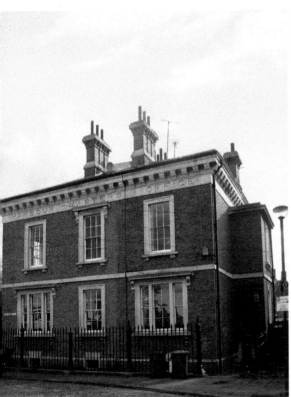 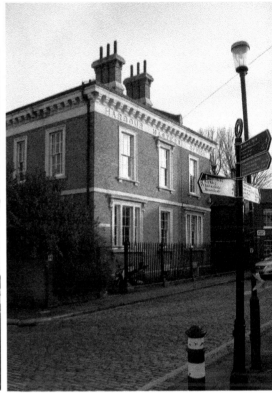

Above left: Refurbished Harbour Master's Office.

Above right: Harbour Master's Office, now divided into private residencies.

Rowlands, the house now a reminder of the days when shipping on the Thames was an important part of the industrial heritage of Greenwich. Constructed as a replacement for an earlier Harbour Master's Office located near the Yacht Tavern, the office controlled movement of colliers on the Thames transporting coal down from the north-east of the country to the Pool of London. The cargoes of coal were required by the emerging industries spreading out along the Thames and across Greenwich Marsh throughout the late nineteenth century and early twentieth century. Most of the coal was used in power generation and on Greenwich Marsh for making town gas and associated coal by-products. The Harbour Master's Office was open from between 9.00 a.m. to 7.00 p.m. every working day, from where colliers received permission to offload cargos of coal under strict control at designated docks, wharfs and quays, a half-red and half-white flag flying from the office signalling no coal laden vessel could proceed onwards to the pool without first obtaining written consent. The colliers were also required to register all coal sold and to report to the harbour master if laying up at dock basins, canals or wharfs under a £10 penalty fine if moving without permission. When coal was moved from Britain's coalfields south by train, collier trade fell into a steady decline, and with legislation changes for regulating movement of shipping on the Thames, the Harbour Master's Office became surplus to requirement and was closed in 1890, the house being converted for residential use.

21. Rothbury Mission Hall, Azof Street

The building of this Grade II-listed mission hall, designed by W. T. Hollands, was funded by Essex-born Josiah Vavasseur, an arms dealer who made his fortune from selling his business interests to another arms manufacturer, William Armstrong, Vavasseur acting as technical director of what would become Armstrong-Whitworth & Co. Ltd. The impressive Gothic-style building, tucked away towards the end of Azof Street, which leads onto Blackwall Lane, was constructed over two storeys in bright red brick with stone voussoirs topped by an extraordinary bell-cast slate roof, with attic rooms, consisting of a central cupola, thin spirelets and timber dormers. The centrally placed entrance, leading into two halls, was flanked by plainly designed but colourful stained-glass windows. After making his fortune, Vavasseur moved from Eltham to a house on Blackheath, donating substantial sums of money to various religious projects, which included establishing a mission hall for Greenwich Congregationalists, the hall named after the village of Rothbury, Northumberland, where the arms dealer lodged while visiting the company armaments factories in the north-east of England. Rothbury Hall was later used by East Greenwich United Reformed Church, before becoming home to visual arts, dance and music entertainments production company Emergency Exit Arts.

Rothbury Mission Hall frontage, Azof Street.

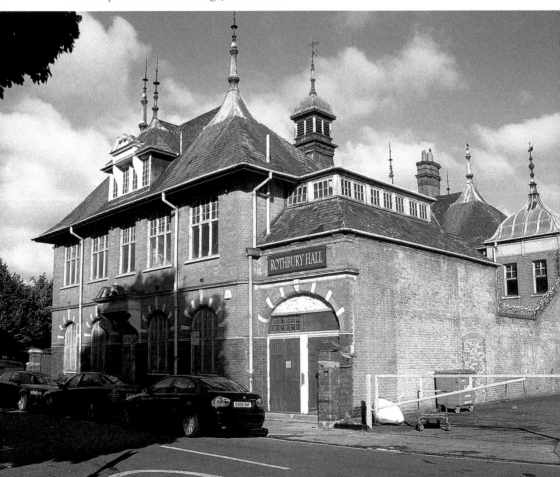

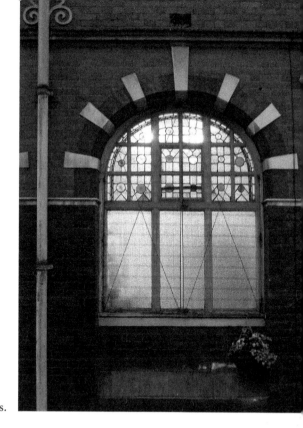

One of Rothbury Hall's stained-glass windows.

22. John Roan School, Maze Hill

Founded in 1677 through a financial bequest recorded in the will of John Roan, Greenwich landowner and Yeoman of Harriers (hunting dogs) to Charles I, the school was established to educate poor children of Greenwich. Although stripped of a majority of his possessions by Parliamentarians during the Civil War, the Royalist left enough of his estate to contribute towards establishing an educational facility close to Greenwich Royal Hospital. First known as Mr Roan's Charity, the school boys' attire consisted of grey cloaks, round hats and leather breeches, and on their upper garments they wore John Roan's coat of arms as the school crest. As admissions to the school increased throughout the following century, the school relocated to larger premises in 1814, built on land at Roan Street, named after John Roan, to the south of St Alfege Church where the school founder was buried. By the mid-nineteenth century the Roan School was also educating girls at a facility on Devonshire Drive, the boys then occupying premises at Eastney Street, the combined total of students numbering over 600. Outgrowing the school's premises spread out across West Greenwich, a new site was acquired towards the top of Maze Hill for the building of a school in a neo-Georgian style designed by architect Sir Banister Fletcher, the building completed in 1928. To the east of the new school a further site was acquired at Westcombe Park Road where sports fields were laid out between the two. During the Second World War, the students were evacuated first to Kent, then Sussex and, after threat of invasion, on to Wales where they were educated until the war's end. When a controversial proposal to relocate the school to a new purpose-built facility at Greenwich Peninsula was ruled out, the allocated funds were invested in refurbishing the Grade II-listed Maze Hill

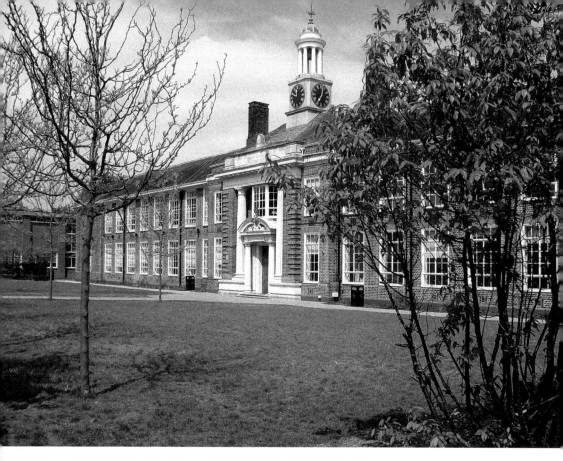

Above: Roan School at the top of Maze Hill.

Left: New John Roan School building, Westcombe Park Road.

School and rebuilding the Westcombe Park campus. Demolished in the summer of 2012, a brand new state-of-the-art facility was then erected in its place, the building receiving the RIBA London Award for architectural excellence in 2015.

23. Trafalgar Tavern, Park Row

Named after Britain's seaborne victory over the combined French and Spanish naval fleets at Trafalgar in 1805, the tavern, designed by architect Joseph Kay, clerk of works to Greenwich Royal Hospital, was erected on the site of an earlier hostelry, the George Inn. Completed in 1837, the Trafalgar Tavern was built over four stories, including attic rooms, the river frontage consisting of long elegant glazed windows and curved balconies with decorative ironmongery. The tavern was made famous through visits by social critic and writer Charles Dickens, featuring the Trafalgar in his novel *Our Mutual Friend*, and Liberal Members of Parliament travelling down river from Westminster by boat to dine on the tavern's famous whitebait dinners, a time when the little silver fish were caught in abundance from the Thames tidal waters. A number of other river inns and taverns also served whitebait dinners including the Ship Inn favoured by Conservatives, which once stood to the south of Greenwich pier, the inn demolished after being damaged in an air raid during the Second World War. The political dinners at Greenwich continued up until Prime

Trafalgar Tavern from the river embankment.

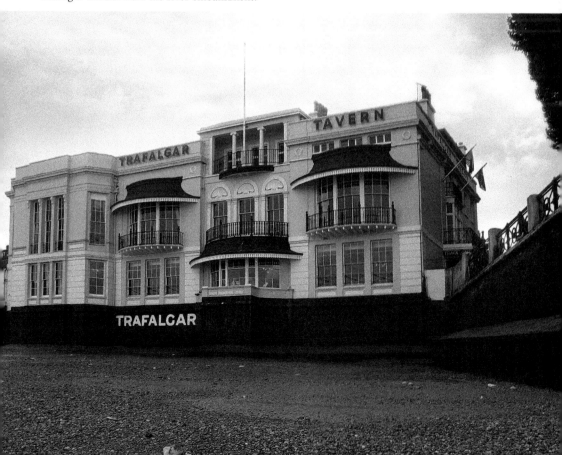

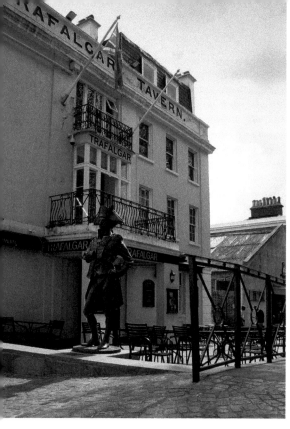

Left: Admiral Lord Nelson welcoming visitors at the main entrance, Park Row.

Below: The famous tavern overlooking the River Thames.

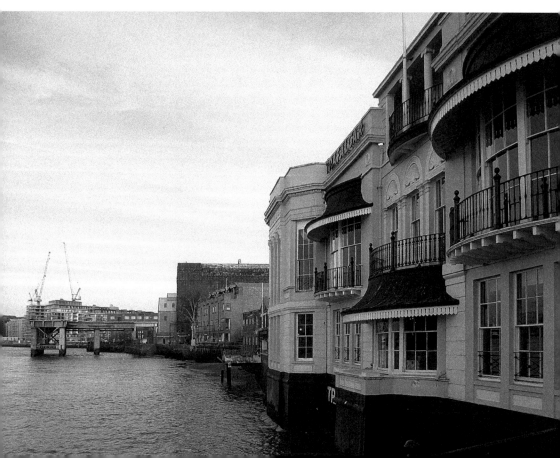

Minister William Gladstone held the last one at the Trafalgar Tavern in 1883, by then the Thames had become heavily polluted killing off the fish. After closing in 1915, to serve as a home for retired seafarers during the First World War, the Trafalgar Tavern was then used as a working men's club before reopening as a public house. Restored in 1968, the tavern's bars and dining rooms, located over several floors, were named after Royal Naval officers including Duncan, Collingwood, Hardy, Howe and Admiral Lord Nelson, whose life-sized bronze statue, by sculpture Lesley Pover, was erected near the tavern entrance in 2005 to celebrate the 200th anniversary of the Battle of Trafalgar. Steeped in naval history, the Trafalgar Tavern is reputedly haunted by an elderly man wearing Victorian clothes, possibly an old seafarer, walking about the upstairs rooms, the figure then disappearing when seen and greeted with a cheerful 'hello'.

24. Greenwich Theatre, Crooms Hill

During the late Victorian and early Edwardian eras, Greenwich became famous for its popular theatrical entertainment venues, all classes of society arriving by horse-drawn coach, riverboat, trolleybus and later by train. Many of Britain's most popular artists of the day performed at Greenwich including actress Ellen Terry, songwriter and singer Arthur

Greenwich Theatre's oldest entrance, Nevada Street.

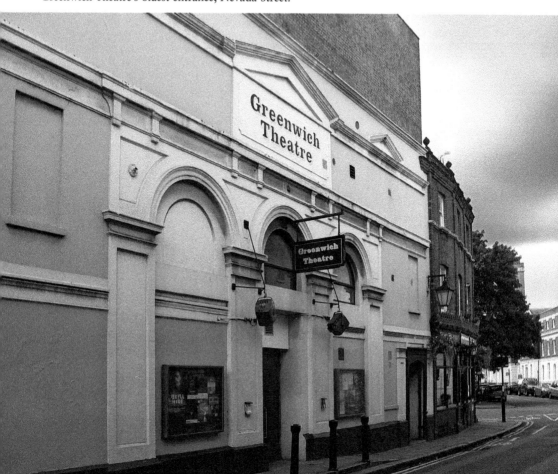

Lloyd, dancer and singer Kitty Fairdale and comedian Dan Leno. Greenwich Theatre, the only theatre to survive from the period, had originally been known as the Rose and Crown Music Hall, established in 1855. The music hall was refurbished in 1871 and renamed Crowder's Music Hall and later the Palace of Varieties. When the Rose & Crown public house on the corner of Nevada Street and Crooms Hill was rebuilt, the adjoining theatre underwent reconstruction in 1895 and a further change of name to the Greenwich Hippodrome. During the early twentieth century there came a gradual fall in attendances at provincial theatres outside of London's West End, especially after the introduction of a popular new entertainment spectacle – talking pictures. The Hippodrome then began showing films as well as putting on live performances. When the theatre lost its live performance licence in 1924 and was only allowed to screen films, the Hippodrome was converted into a picture house. The theatre was eventually forced to close its doors to the public when it was damaged by an incendiary bomb during the Second World War. In 1962, the theatre was facing demolition until a successful campaign fought by theatre lovers and local celebrities saved the building from destruction. Following extensive renovations to the interior and main entrance, the old stage door entry on Nevada Street was left much the same in appearance as it had been during the theatre's heyday; the New Greenwich Theatre reopened in 1969 with a contemporary musical performance of Martin Luther King. Greenwich Theatre is now a progressive entertainments venue where performances include a range of classical and modern dramas and a variety of comedy and musical productions.

Below left: Rose & Crown public house, on the site of the former music hall.

Below right: New Greenwich Theatre foyer entrance, Crooms Hill.

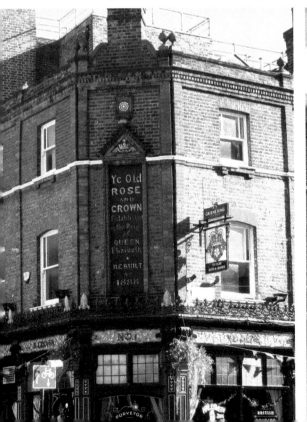 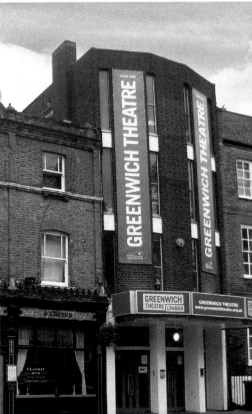

25. Mumford's Flour Mill, Greenwich High Road

Situated on the south bank of Deptford Creek, the tidal waterway also known as the River Ravensbourne, or Quaggy, the large brick-built Mumford's Flour Mill was erected in 1897 on the site of a former wooden tide mill founded in 1790 by the Mumford family of millers. At the time of the Norman invasion there were several tidal mills situated along Deptford Creek producing flour from corn brought up the Thames by barge from the fields of Kent and Essex. It was not until the grain milling industry went through a period of radical change during the Industrial Revolution that tide mills, using traditional methods of milling flour by grind stone, were made redundant and replaced by steam-powered mills using new state-of-the-art steel rollers. Designed by Sir Aston Web and Ingress Bell, the mill, built mainly in stock brick with some excellent decorative stonework friezes, was the last of all the mills to have survived on the tidal creek. The adjacent Robinson's Mill, of equal size and importance as Mumford's, was demolished in 1970 after a fire. The impressive Italian-style grain silo, erected at the end of the main Mumford's Mill building, was constructed using the most modern architectural specifications of the time, which included metal internal framing and

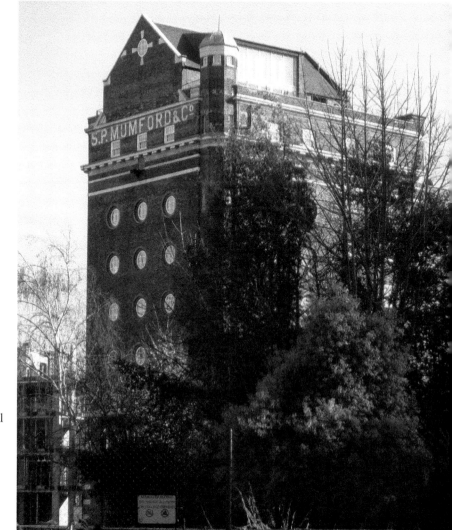

Former Mumford's Mill 1897 grain silo converted into apartments.

Above left: Main building of Mumford's Mill, Greenwich High Road.

Above right: Refurbished Mumford's Mill residential gated entrance.

the latest fireproof technology. The silo was also designed by Sir Aston Web, the architect responsible for designing Admiralty Arch, the Victoria and Albert Museum's Cromwell Road frontage, and the eastern façade of Buckingham Palace. Owned by the Mumford family up until acquired by the Rank Group during the 1930s, when the mill ceased producing flour, the Grade II-listed building, rated by English Heritage as one of Britain's finest flour mills, was converted into luxury apartments in the early twenty-first century. A set of locked gates now bars access to the historic Mumford's Mill to all but its residents.

26. Royal Kent Dispensary, Greenwich High Road

Founded in 1783 by Revd Canon John Cale Miller, vicar of St Alfege Church, the Kent Dispensary, originally located at a property on Deptford Broadway, was granted royal patronage in 1837 by Queen Victoria, and renamed the Royal Kent Dispensary. Relocating to newly built premises on Greenwich High Road in 1855, a charitable hospital was erected next to the dispensary in 1883, named the Miller Hospital in honour of the dispensaries founder. The hospital was the first in Britain with circular wards, the shape believed to allow for better ventilation as there were no corners to harbour germs and stale air. The hospital was extended to include a surgical block, new wing, out-patients department and a nurse's home, erected in Catherine Grove. The hospital complex was renamed the Miller General Hospital. Administered by the National Health Service between 1948 and 1974, the hospital, along with the dispensary, became a wing of Greenwich District Hospital. Considered much too expensive to modernise, the hospital was closed despite a public outcry, and a majority of the buildings were demolished in 1975 to make way for residential housing; only the chapel, nurses' home and listed Royal Kent Dispensary building survived.

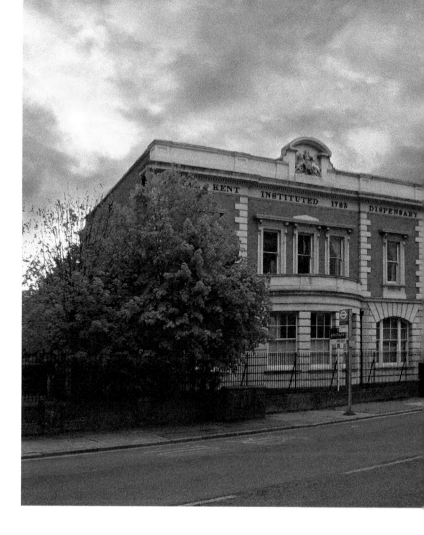

Kent Dispensary,
Greenwich
High Road.

27. The Pagoda, Pagoda Gardens

The Pagoda was built in 1767 for the Duke of Montague as the garden tea house on
the estate of Montague House, Blackheath. The property was notorious for its raucous
parties held by Caroline of Brunswick, wife of George IV. While in residence during the
early 1800s, the queen faced accusations of inappropriate sexual behavior that led to an
investigation by a Royal Commission. After the queen was acquitted and left England
for Europe, Montague House was demolished in 1815, but the Pagoda tea house
was left standing. The Pagoda had been built at a time when Chinoiserie, a European
interpretation of Chinese and East Asian art and design, became stylish in Britain after
trading vessels sailing to the Far East returned laden with cargos of exotic goods, silks,
decorative porcelain, furniture, fine art, spices and tea. Many country properties during
this period had a tea house or a room decorated with oriental style-wallpaper, furniture
and chinaware for holding afternoon tea parties, which became a popular aristocratic
pastime. Designed by Sir William Chambers, architect of Somerset House and the
Pagoda at Kew, the Blackheath Pagoda was constructed over three stories in stock brick
with red-brick decoration. The upper floor was fitted with large circular and elliptical

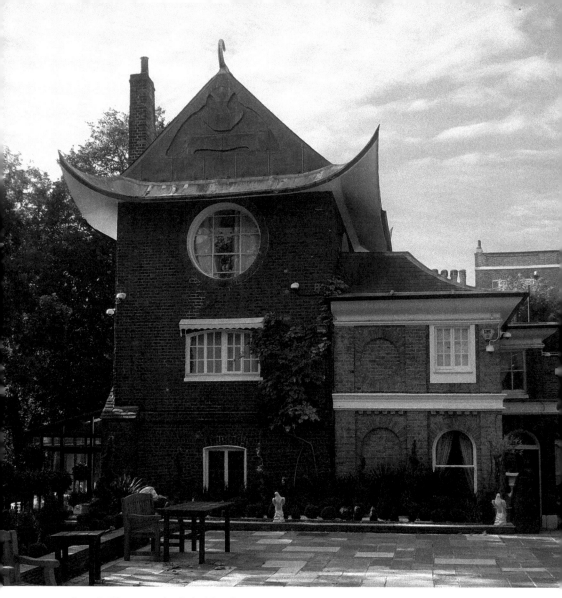

Pagoda House south of Blackheath.

moon-shaped windows and the building was topped by a large gabled Chinese-style roof clad in lead with upwardly curving eves embellished with copper horns. The extensive grounds, part of the Montague estate, were ornamentally landscaped and incorporated walled fruit and vegetable gardens. Extended during the nineteenth century, the tea house became a spacious mansion, the splendid interior including a wooden panelled hall, a wooden turned staircase, dining room, drawing room, billiard room, kitchen, and several spacious bedrooms. Acquired by the local authority during the mid 1900s, the Pagoda became a children's home and then a residence for refugees. Over several years the building fell into a poor state of repair, and a majority of grounds had been transformed into a housing estate named Pagoda Gardens. Towards the late 1990s, after the Pagoda came under private ownership, the building and what remained of the property's gardens were restored.

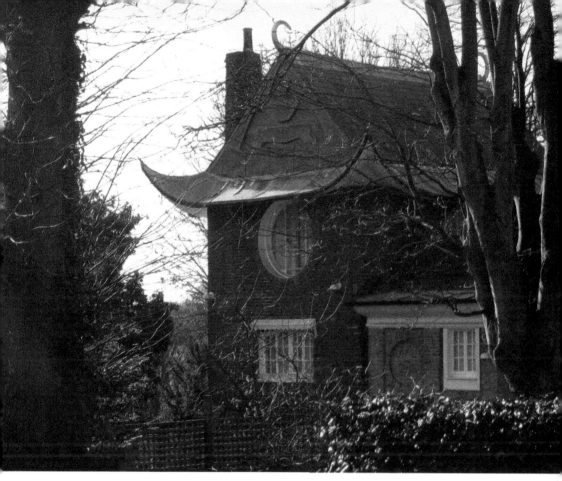

The former tea house is now surrounded by trees and residential properties.

28. Greenwich Railway Station, Greenwich High Road

London's first steam passenger railway, the London to Greenwich line, received parliamentary approval in 1833 and was fully operational by 1838. The track ran from Tooley Street, London Bridge, via Deptford to a terminus at Greenwich, west of the town centre. The first locomotives, Stephenson's Planet design, pulled carriages on a track that for the most part ran along a high straight viaduct, the earliest elevated railway ever to be built. The 878-arch viaduct was constructed by over 400 navies laying 100,000 bricks a day, which caused a national brick shortage. The line, ending at the temporary station, would later run eastwards into the countryside and onwards to the Kent coast. As the number of passengers using the railway grew, locally based architect George Smith was commissioned to design a larger station to replace the previous terminus. The impressive new building, completed in 1840, is believed to be the oldest surviving railway station in the world. Within ten years the railway was carrying 2 million passengers annually. Undergoing various refurbishments during the late 1900s, the station was extended to include platforms for the London Docklands Light Railway, opened in 1999, to carry commuters under the Thames to the new business and financial centre of Canary Wharf.

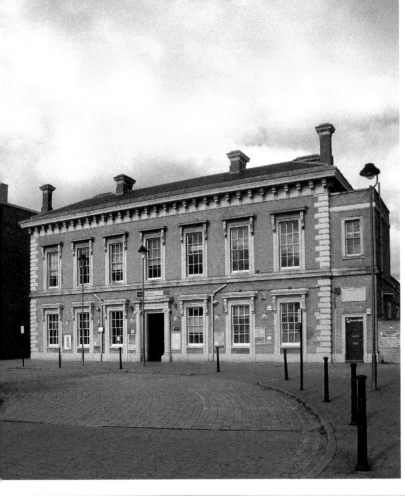

Left: Greenwich Interchange Station, Greenwich High Road.

Below: North Kent extension line being built from Greenwich Station during the 1870s.

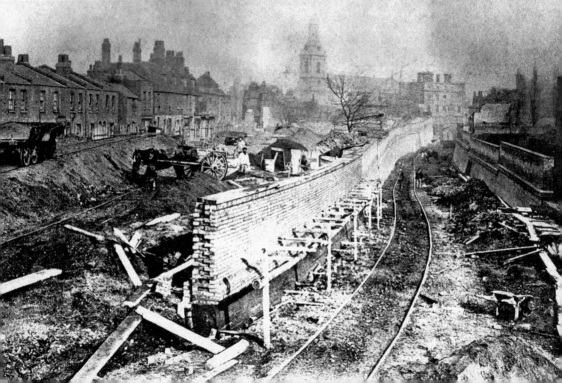

29. Gloucester Circus, Crooms Hill

Designed towards the end of the eighteenth century by local architect Michael Searles, Gloucester Circus had been planned to form an almost full oval with two matching cresents of elegant properties, three stories high with attic and basement, facing each other across an area of green space. At each end of the oval access roads led onto Crooms Hill, a former Anglo-Saxon thoroughfare running from Blackheath to the town centre, and Royal Hill, named after property developer and builder Robert Royal. Financing of Gloucester Circus, a speculative building project, relied heavily upon income secured from properties taken up on completion to continue funding the ongoing build. However, lack of interest caused the project to run out of money with only three-quarters completed. Houses were later built on the open side, similar in appearance to the properties opposite, but in a straight line. Instead of London's wealthy taking up residence as intended, the houses became dwellings of the working class. After the area was bombed during the Second World War, the damaged properties to the north side of the circus were demolished and plain modern blocks of flats were erected in their place during the mid-1900s.

Original houses built in a crescent on the south of Gloucester Circus.

Surviving properties erected to the north of Gloucester Circus.

3c. Greenwich Foot Tunnel, Cutty Sark Gardens

Designed by Sir Alexander Binnie, the foot tunnel ran below the River Thames from the south bank, near to Greenwich Pier, to the north bank at Island Gardens on the Isle of Dogs. Foot passengers entered the tunnel, lying 380 feet below sea level, by climbing down a spiral staircase or descending in an attendant-operated lift located in deep shafts under a large circular red-brick glass-domed structure, one erected each side of the river. The tunnel had been built as a free alternative for workers to cross the river rather than using the costly and unreliable ferry services, the ferries being unable to sail in poor weather conditions, high winds and rough waves. Construction on the tunnel began in 1899 and was completed and ready for use by 1902.

The tunnel, clad in cast-iron rings, coated in concrete and lined with 200,000 ceramic tiles, was just over 370 meters in length. When the tunnels north end was damaged by a falling bomb during the Second World War, the bore required restrengthening by applying layers of concrete reinforced with thick curved steel panels, the repairs visible to foot tunnel users today. A byelaw prohibits cyclists riding through the tunnel, and although listed as a London cycle route, bikes must be carried or pushed through. When lifts were attendant operated, cyclists could remount their bikes when halfway through as the dip at the centre

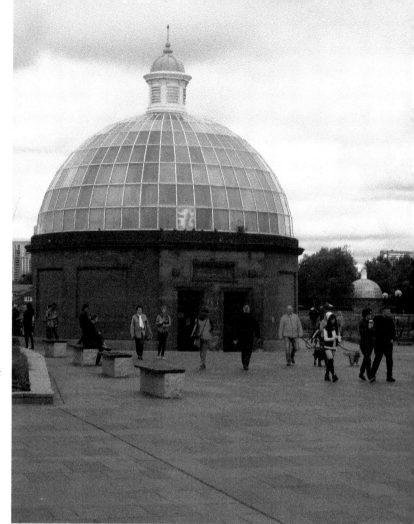

Right: Greenwich Foot Tunnel's south bank entrance with the north bank entrance in the distance.

Below: Plaque erected above the tunnel entrance commemorating its opening.

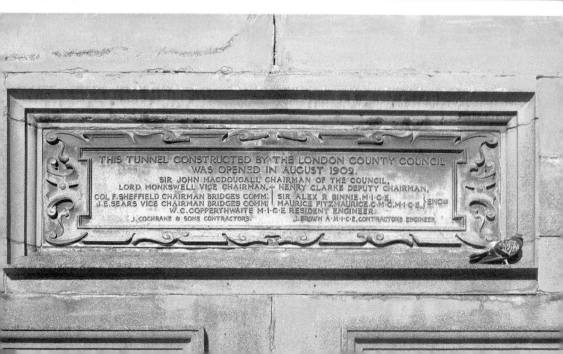

THIS TUNNEL CONSTRUCTED BY THE LONDON COUNTY COUNCIL
WAS OPENED IN AUGUST 1902.
SIR JOHN MACDOUGALL CHAIRMAN OF THE COUNCIL.
LORD MONKSWELL VICE CHAIRMAN. ~ HENRY CLARKE DEPUTY CHAIRMAN.
COL F. SHEFFIELD CHAIRMAN BRIDGES COMM! | SIR ALEX R BINNIE, M·I·C·E,
J.E. SEARS VICE CHAIRMAN BRIDGES COMM! | MAURICE FITZMAURICE, C·M·G, M·I·C·E, } ENG!!
W.C. COPPERTHWAITE M·I·C·E RESIDENT ENGINEER.
J. COCHRANE & SONS CONTRACTORS. J. BROWN A·M·I·C·E, CONTRACTORS ENGINEER.

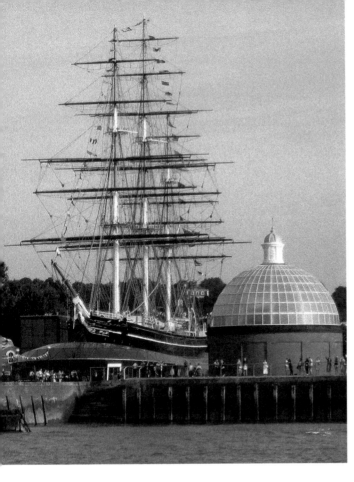

Tunnel entrance and *Cutty Sark* clipper viewed from the River Thames.

of the tunnel obscured them from the lift attendant's view. The foot tunnel, open twenty-four hours a day, can be a rather spooky place to be when walking through alone late at night. So far there have never been reports of any ghostly apparitions appearing to solitary foot passengers while making their way through. However, the echo of their own footsteps can sound very much like they are being followed by an unseen spectral presence.

31. Magistrates' Court, Blackheath Road

The former police station and police court located on Blackheath Road, built in 1909, was designed by John Dixon Butler, architect for the Metropolitan Police. Erected in brick and faced with Portland stone, the two-storey building with attic rooms also had a basement where prisoners awaiting appearance in court were held in cells. On the symmetric classical-design frontage, a large stone royal coat of arms carved by architectural sculptor Lawrence Arthur Turner, master of the Art Workers Guild and member of the Society of Antiquaries, is mounted high above the main entrance doorway.

The interior of the magistrates court consists of a large police foyer inside the main entrance, which has a sizeable mosaic tile floor inset with Metropolitan Police emblems, a principal courtroom with a plasterwork Edward VII crest above the bench, two further minor courtrooms, judge's chambers and various administrative rooms and offices. The building was originally fitted out in wood panelling and a central wooden staircase,

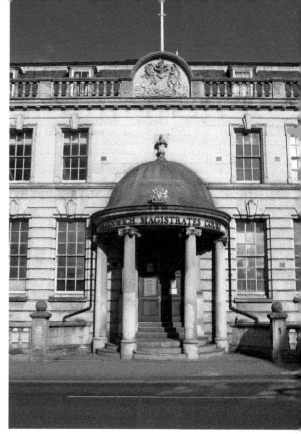

Right: Magistrates' Court main entrance with carved royal coat of arms above.

Below: Greenwich Magistrates' Court on Blackheath Road.

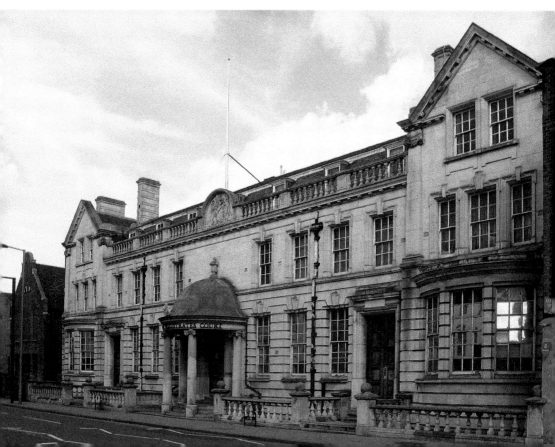

handrail and balusters. The leaded lights and stained glass are attributed to William Morris, and a majority of the rooms and chambers were decorated with plasterwork designs. Police courts dealt mostly with cases concerning criminal offences of a less serious nature: assault, drunk and disorderly conduct, theft, soliciting and possessing stolen goods. Following the 1964 Administration of Justice Act, police courts were integrated with lay magistrates to form Inner London Magistrate Courts. It was at Greenwich Magistrates' Court in 1995 where the first private prosecution in modern legal history took place when the parents of murdered teenager Stephen Lawrence obtained warrants at a private hearing within the court for the arrest of those accused of the youngsters killing. When the Ministry of Justice announced the closure of eighty-six courts across the UK in 2016, the Grade II-listed Greenwich Magistrates' Court was one of those selected for closure. The building is likely to be redeveloped as a hotel.

32. Blackwall Tunnel Gatehouse, Blackwall Tunnel Southern Approach

To make way for the construction of Blackwall Tunnel, it was necessary to relocate a small community of Greenwich Marsh residents from their dwellings, which were then demolished before work could begin in 1892. Designed by Sir Alexander Binnie and built by Yorkshire construction company S. Pearson & Son, the single bore Blackwall Tunnel took five years to build and on completion became the longest tunnel ever constructed under a river. Officially opened in May 1897 by Edward Prince of Wales on behalf of Queen Victoria during the Silver Jubilee Year, the tunnel was regarded as the twenty-first wonder of the world. Originally classical-style arches were planned to be erected across the approach road of both north and south entrances, the arch measuring the same height as the tunnel

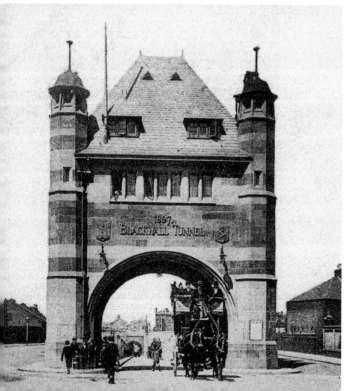

The gatehouse when Blackwall Tunnel first opened in 1879.

from the carriageway, 17ft 6in, to gauge if horse-drawn loads would be too big to pass through. The bore, lit by incandescent lamps, was constructed with sharp bends, rather than in a straight line, to prevent horses bolting towards the daylight at the tunnels end. The original gateway design was superseded by magnificent art nouveau two-storey rectangular arched gatehouse, designed by London County Council architect Thomas Blashill. Built in contrasting red and light-brown sandstone, the gatehouse featured octagonal turrets, one in each corner of the building, rising up towards the tiled pitched roof. The gatehouse interior, above the archway, included family lodgings for a superintendent and a caretaker, accommodation comprising of a bedroom, a living room, scullery, larder and ablutions. Each gatehouse exterior featured stonework coat of arm shields representing Kent, Surrey, Middlesex and Essex, the four counties the tunnel was built to service. When opened the tunnel was mainly used by horse-drawn vehicles, cyclists and pedestrians, which were later all banned to allow motorised vehicles full access. The northern gatehouse of Blackwall Tunnel was demolished in the 1950s to make way for a second tunnel to accommodate an increase in traffic. However, the Greenwich gatehouse has survived.

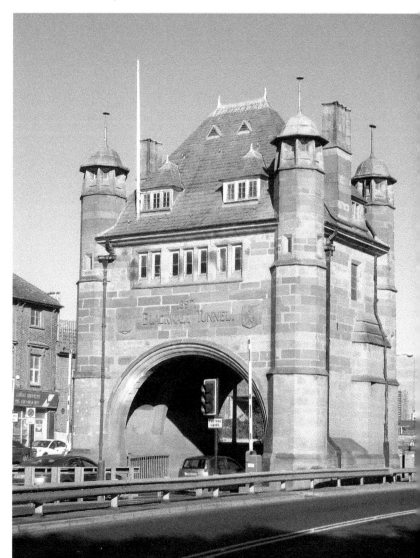

Gatehouse on southern entrance of Blackwall Tunnel.

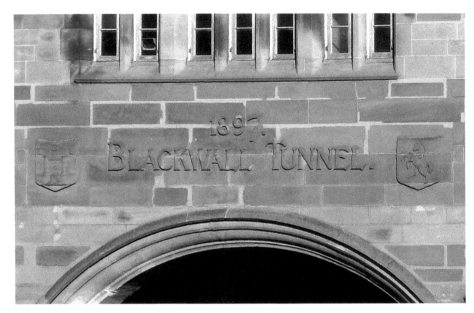

County coats of arms above the gatehouse arch leading into the tunnel.

33. National Maritime Museum, Romney Road

Originally built during the early nineteenth century as the Greenwich Royal Hospital School where children from seafaring backgrounds were boarded and educated, the school buildings included the existing Queen's House, commissioned in 1616 by Anne of Denmark and designed by the Surveyor of the King's Works Inigo Jones. After the Queen's House

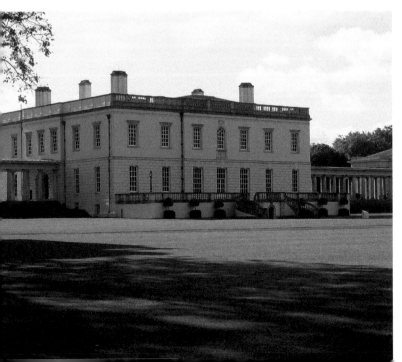

The Queen's House erected during the early seventeenth century.

was donated by George III in 1806 for use of the school, east and west wings were added connected by long colonnaded raised walkways. On completion in 1815, 800 children were in education at the school. When the Royal Hospital School relocated to Holbrook, Suffolk, the buildings were acquired through the National Maritime Act of 1934 for use as a maritime museum. With a board of trustees and a generous donation from Glasgow-born shipowner Sir James Caird, collections of marine art and naval artefacts once stored at the Royal Naval College opposite, were then able to be put out on display. Formally opened in 1937 by George VI, accompanied by eldest daughter Princess Elizabeth, the National Maritime Museum exhibits represented a thousand years of maritime history.

Since the museum first opened, the buildings and galleries have been updated and regularly refurbished for the display of artefacts held in storage, loaned or purchased by the museum. In 1999, through financing secured from the Heritage Lottery Fund, the main galleries were redesigned and the new Neptune Gallery unveiled, a large contemporary enclosed exhibition space spanned by a huge glass roof canopy. The Queen's House, described as the first classical building in England, was restored as a place of royal residence in 2001, the elegantly decorated house interior consisting of a great hall, royal apartments, an orangery and an undercroft, the walls adorned with magnificent artworks from the museum's extensive art collection. In 2011, the largest development in the history of the museum, the Sammy Ofer Wing, was opened to the public. Dedicated to the Israeli shipping tycoon Sammy Ofer, who donated £20 million towards a £35-million expansion, the new wing gave the museum the opportunity to stage temporary themed exhibitions and shows. Also included within the Sammy Ofer Wing was an additional new exhibition gallery, a restaurant, café and ultra-modern state-of-the-art library and archive.

Below left: Main entrance of Greenwich Maritime Museum, Romney Road.

Below right: Sammy Ofer Wing entrance next to a gigantic ship in a bottle.

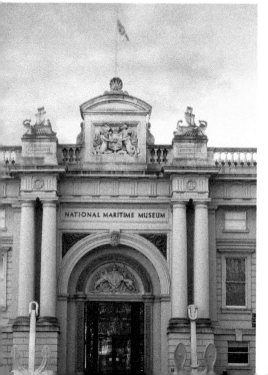
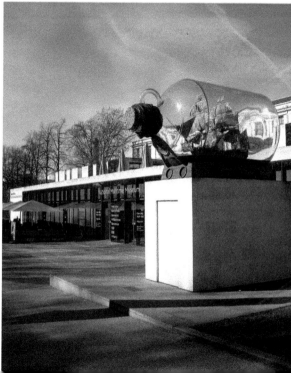

34. Greenwich Park Tea Pavilion, Blackheath Avenue

Designed by Sir Henry Tanner, Principle Surveyor of the London Office of Works, the two-storey octagonal tea house was built in Greenwich Park between 1906 and 1907, at a cost of £1,066. The tea house was erected on the site of a pavilion, dating to 1875, surrounded by various temporary refreshment tents. Situated close to the junction of Blackheath Avenue and Great Cross Avenue opposite the Royal Observatory, the new tea pavilion was a simple rustic-style structure based on a similar tea house in Kensington Gardens. Consisting of a main building from where tea and refreshments were provided, an extension to the rear of the tea house served as a kitchen area, storage and toilet. The initial architectural drawings show a short Chinese-style turret at the centre of the circular tiled roof, from where an elaborately fashioned weather vane, in the shape of a sailing ship, was positioned on top. The ship design was rejected in favour of a simpler figure of a bird; however, the roof was eventually topped by a decorative dovecot and a weather vane in the form of a naval officer, possibly Admiral Nelson, looking through a telescope. When refurbishments were carried out in 1967, the upper balustrade was removed and the open veranda running around the circumference of the tea pavilion ground floor was enclosed with Georgian-style glass windows and main entrance doors. The recently renovated interior consists of a bright large airy open dining space, furnished with sets of tables and chairs, a serving area and staircase leading to the upper dining room floor, with views looking out over the pavilion tea house terrace and gardens. Bordered by a fence and a variety of trees and shrubs, parasol picnic tables are positioned across the large lawn area where customers can take tea outside on sunny summer days.

Pavilion Tea House on completion in 1907, Greenwich Park.

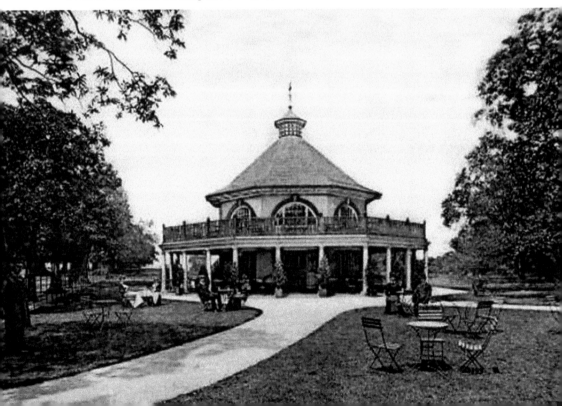

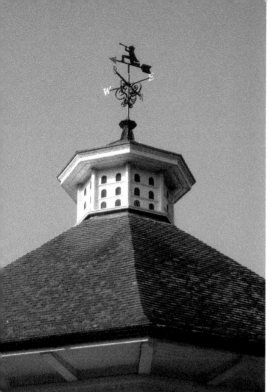 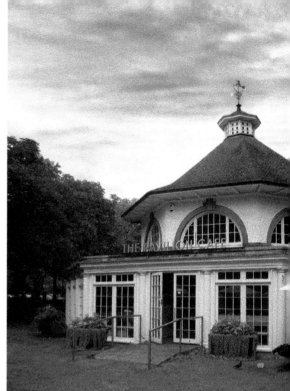

Above left: Tea House dovecot and weathervane.

Above right: The Pavilion Café main entrance.

35. Greenwich Power Station, Old Woolwich Road

The imposing structure of Greenwich Power Station, designed by London County Council's architect W. E. Riley, was built in two sections between 1902 and 1910 on the former grounds of a Jacobean mansion, Crowley House. The mansion was owned by ironfounder Sir Ambrose Crowley, who made his fortune producing ships anchors and shackles and chains for the slave trade. When the house was demolished for salvage in 1853, the grounds were used as a horse-drawn tram depot. After plans were made to electrify tramways the power station was erected on the site, its coal-fired steam engines generating electricity to run London's tram network, the surplus used as reserve power for London's underground system. As huge quantities of coal were needed to fuel the power station's steam engines, a large jetty was constructed on the river to offload coal from colliers and remove coal ash residue for disposal by barge. The original power station steam engines were replaced by more efficient steam turbine alternators in 1922, and then by oil-fuelled Rolls-Royce gas turbines similar to jet engines. There are now plans to install six new gas turbines to provide low-carbon energy to power London's Tube system and supply heat and hot water to local schools and homes. The power station's tapering octagonal chimneys erected in the first phase measured almost 250 feet high. The chimneys built during the second stage were smaller, just 180 feet high, all four visible from across the Greenwich landscape. These four distinctive chimneys were later truncated to two-thirds their height, ruining the building's visual proportions. To the south-east of the site stands a high brick-built turret,

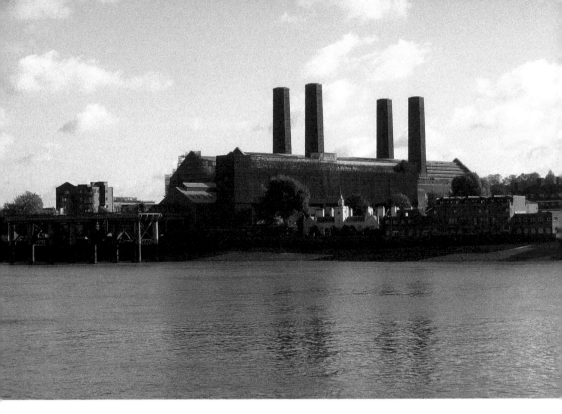

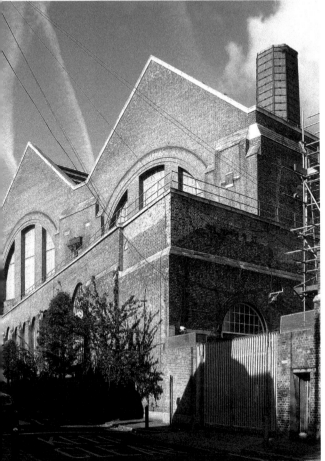

Above: Greenwich Power Station and the Coal Jetty to the left.

Left: The great edifice of Greenwich Power Station, Old Woolwich Road.

A mysterious tower to the south-east
of the power station buildings.

which is only accessible through a door in the abandoned station masters house, the key
long gone missing, the door barring entry to anyone attempting to discover what mysteries
may be hidden within. On the power station's boundary wall facing the Thames close to
where the Meridian Line crosses the public pathway, a three-dimensional art installation,
A Thames Tale, created by artist Amanda Hinge, was mounted into the brickwork during
the millennium year, the story depicting the adventures of a Greenwich mudlark.

36. Up the Creek, Creek Road

Situated on Creek Road east of a lift bridge spanning the tidal Deptford Creek, an
unoccupied late nineteenth-century mission hall, once St Peter's Church Sunday school,
was renovated and rejuvenated in 1990 to become a quirky jazz comedy club founded
by veteran of the Soho Comedy Store Lewisham-born Malcolm Hardee. The popular
but outrageous comedian accidentally drowned in Greenland Dock, Rotherhithe,
on New Year's Eve 2005. Hardee is believed to have fallen into the water late at
night while returning from the floating pub he owned, the *Wibbley Wobbley*, to his
houseboat the *Sea Sovereign*. On recovery of his body, police reported Hardee was still
clenching a bottle of beer tightly in his hand. Up the Creek opened in October 1990.
Acts appearing at the club have included Russell Brand, Michael McIntyre, Russell
Howard, Al Murray, Sarah Millican and a host of top musicians and alternative comedy
performers. In 2016, a £20-million housing development on Creek Road included the

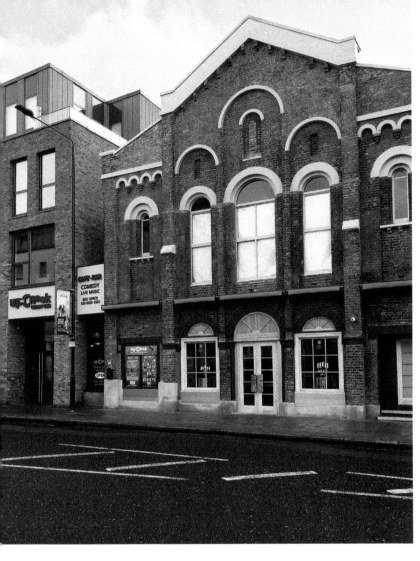

Up the Creek
Greenwich Comedy
Club, Creek Road.

refurbishment and expansion of the legendary comedy club, the blocked front windows were opened up and the purple painted façade cleaned up and restored to its original stock brickwork, although the building's unconventional attraction has now been lost since the renovation.

37. Devonport House, King William Walk

The earliest part of this building complex, designed by clerk of works William Newton, was erected between 1783 and 1784 as an educational facility for boy's resident at Greenwich Hospital School, now the National Maritime Museum. Converted from an educational facility to an infirmary, by 1882 various ancillary buildings and an additional ward had been added. In 1923, the infirmary was acquired by the Seamen's Hospital Society to expand the overcrowded Dreadnought Seaman's Hospital and nurses' home opposite, the hospital named after HMS *Dreadnought* once moored off Greenwich Reach, the floating hulk, veteran of the Battle of Trafalgar, used as an infirmary for sick and injured

merchant seamen. After chairman of the Port of London Authority Lord Devonport successfully campaigned to raise funds to finance the hospital expansion, architect Sir Edwin Cooper designed an impressive new nurses' home to be built at the front of the existing nineteenth-century infirmary. However, as the new building would encroach upon the former naval burial ground, an Act of Parliament had to be passed permitting the sailors' remains to be removed and reinterred at Greenwich Pleasance burial grounds, East Greenwich, before building work could begin. Opened in 1929, Devonport House, named after fundraiser Lord Devonport, comprised of accommodation for 130 nurses including bedrooms, kitchenettes, sitting rooms, recreation rooms and classrooms for study. A new out-patients department and separate pathology unit were also built to the west of the nurses' home. Devonport House was erected in a position to ensure the former cemetery's mid-eighteenth-century Grade II-listed mausoleum was left undisturbed, the vault containing the bodies of Royal Naval officers including Admiral Hardy and Lord Hood laying alongside the only non-commissioned sailor, Tom Allen, Nelson's personal servant aboard *Victory*. Through the decline of merchant shipping fleets and fall in the number of merchant seamen admitted to the hospital, along with national changes to health authority administration, the Dreadnaught Hospital closed in 1986, followed soon after by the closure of Devonport House. The buildings were sold for redevelopment as a hotel and conference centre, the former pathology lab converted for use as Greenwich University's students' union building.

Devonport House, former nurses home, King William Walk.

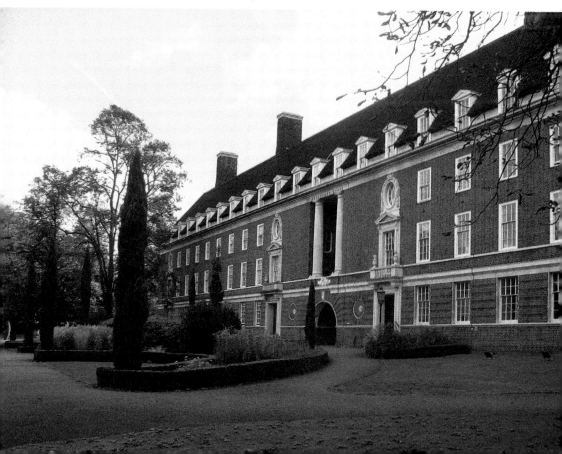

In Memory of
THE GALLANT
OFFICERS AND MEN
OF THE ROYAL
NAVY AND MARINES
TO THE NUMBER OF
ABOUT TWENTY THOUSAND,
FORMERLY INMATES OF
THE ROYAL HOSPITAL
GREENWICH,
WHOSE REMAINS WERE
INTERRED IN THIS CEMETERY
BETWEEN THE YEARS
1749 AND 1869.

ERECTED BY ORDER OF
THE LORDS COMMISSIONERS
OF THE ADMIRALTY
1892

Admiralty naval memorial to former inmates once buried in the grounds.

38. Greenwich Town and Borough Hall, Royal Hill

Designed by architect Clifford Culpin, the Grade II-listed art deco-style council building was erected in 1939 on the site of a lecture hall and Morton's Music Hall at the corner of Greenwich High Road and Royal Hill, the road widened when the site was cleared ready for building. Constructed in reinforced concrete clad in red brick, the building was inspired by Dutch architect W. M. Dudok's Hilversum Town Hall, considered one of the most influential buildings of the time. The elegant clocktower of Greenwich Town Hall, once open to the public, situated to the north-east corner of the building offered spectacular views over Greenwich and beyond from an enclosed observation platform at the very top of the 50-metre-high tower. The people of Greenwich used the Town Hall as a refuge during the Second World War when the basement was converted into an air-raid shelter. The building's interior, containing various civic and administrative offices, civic suite and public halls, had been designed to resemble the inside of an ocean-going liner. Although escaping damage from bomb strikes during the Blitz, one high-explosive bomb narrowly missed the Town Hall, falling on buildings on the opposite corner of Royal Hill. Much of the seagoing decor was lost during the building's refurbishment in the early 1970s. The large main hall was used for various civic and private functions, theatrical performances

Iconic Greenwich Town Hall clock tower.

Meridian House's main entrance, Royal Hill.

and ballroom dances, which were particularly popular during the 1930s. When the Metropolitan Borough of Greenwich merged into the London Borough of Greenwich during the 1960s, civic administration transferred to Woolwich Town Hall. Renamed Meridian House, the interior was divided up for use as office space, the Greenwich School of Management taking up residence, and the halls became home to Greenwich Dance.

39. Thames Flood Barrier, Unity Way

In the aftermath of the North Sea Flood of 1953, when large areas of the Thames Estuary and East London came under flood water, a plan was devised to build a barrier across the Thames to prevent North Sea storm surges and high tides submerging the Greater London floodplain. Designed by civil engineers Rendel, Palmer and Tritton, the barrier comprised of a revolutionary new rotating gate system to hold back the floodwaters, a concept devised by Reginald Charles Draper in 1969. Work began in 1974, at an area on the Thames, Woolwich Reach, where the chalk riverbed was strong enough to support the massive barrier structure. Spanning 520 meters across the river, the barrier consisted of individually spaced piers clad in stainless steel, which contained the machinery used for raising and lowering the rotating floodgates positioned in between the piers. The project took eight years to complete at a

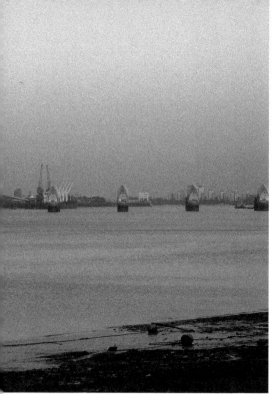 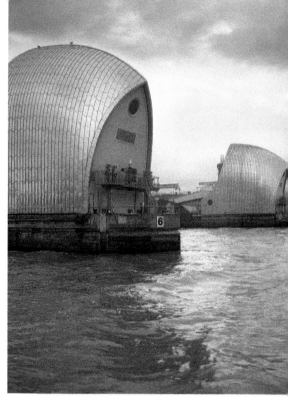

Above left: Thames Barrier stretching across the river from New Charlton to Silvertown.

Above right: Stainless steel-clad gate pier viewed from the river.

Below: Piers housing hydraulically operated gate arms and rocker beams.

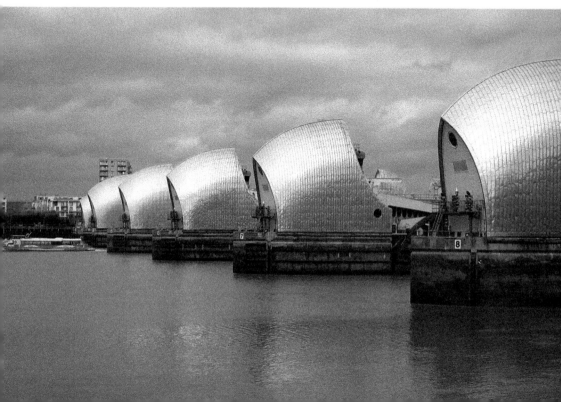

cost of £535 million, with an additional £100 million spent on raising and strengthening the Thames river defences. Although officially opened by Elizabeth II in May 1984, the barrier was operational two years earlier and used for the first time in February 1983. A visitor information centre on the south bank of the river at New Charlton, adjacent to the barrier operations tower, has various exhibits and displays detailing the history of the Thames barrier and how the machinery and floodgates works. Although visitors are not permitted to venture onto the Thames Barrier, the pioneering structure has been used as a location for several television and film productions including *Spooks*, *Doctor Who* and the disaster movie *Flood*.

40. The O2 Arena Centre, Peninsula Square

Towards the end of the twentieth century Greenwich Marsh, a landscape once crowded with industrial buildings, boatyards, refineries and chemical, cement and aggregate works, had become a neglected wasteland. With the Meridian Line running through the north-west corner of the marsh, the site was an ideal location to build a futuristic exhibition centre, the Millennium Dome, to celebrate the turn of the twenty-first century. Designed by architect Richard Rogers, the dome's huge exterior, a white circular canopy made out of tensioned fabric stretched over a steel frame, measured 365 metres in diameter, the figure corresponding to the number of days of the year. The dome was supported by twelve giant yellow tubular metal struts connected by a network of high-tension support cables,

The Millennium Dome, Greenwich Peninsula.

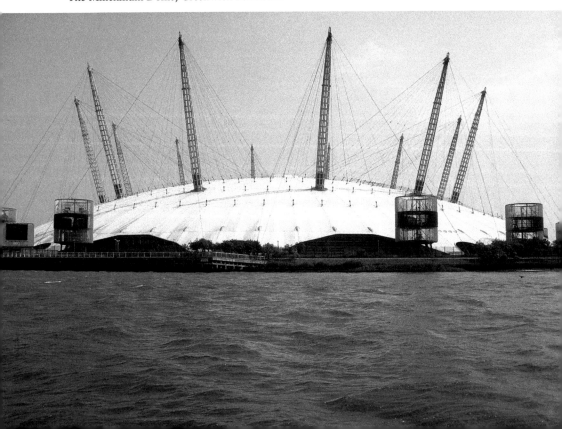

each strut representing hours on a clock face and months of the year. On completion the Millennium Dome opened to the paying public on 1 January 2000, the interior housing the Millennium Experience, an exhibition divided into themed zones with a stage at its centre where a millennium musical extravaganza was performed 999 times during the following year. Although around £780 million had been spent on the project, the venture became a financial failure, the annual attendance falling well below expected numbers, a majority of the zones and exhibits said to be lacking in inventiveness and innovative content. After its closure the Millennium Dome, branded a great white elephant, was estimated to be costing £1 million a month to maintain. Subsequently used as a venue for independently run exhibitions and musical concerts, as well as a shelter for the homeless, in 2005 the Millennium Dome was rejuvenated to become a financially successful state-of-the-art concert, sport and exhibition centre in a sponsorship deal with the European telecommunications company O2. Above the canopy of the O2 Arena, as the venue became known, a steep suspended walkway, opened in 2012, leading climbers to a raised platform at the very top, 52 metres above ground level, each metre representing a week of the year, where on their arrival they are rewarded with magnificent panoramic views over London.

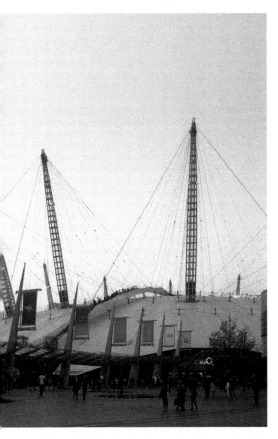

Above left: Peninsula Square leading to the O2 entertainment venue.

Above right: Climbers making their way to the top of the O2.

41. Peninsula Ecology Park Gatehouse, Olympian Way

Once known as Greenwich Level, which, as the name implied, was an area of level lowland, the wide expanse projected northwards from East Greenwich and was bounded by the Thames flowing in a loop around west, north and part of the east of the marsh. The remainder of the boundary was made up from a flood barrier, Lombarde's Wall, and to the south by Woolwich Road. Up to the mid1700s the wetland had been used mostly for grazing livestock with few structures breaking up the flat landscape apart from a scattering of cowsheds and barns. By the late 1800s, the marsh had become heavily industrialised and a majority of the natural environment and wildlife habitation was lost. When the regeneration of Greenwich Marsh took place towards the end of the twentieth century leading up to the millennium celebrations, to bring back a natural element of the marsh an ecology park, designed by Dr Mike Park, was created over an area of 4 acres to the east of the level resembling how the wetland appeared before industrialisation. The park, managed by wardens and volunteers, consists of seven main habitats with two lakes, shingle beach, shallow wetlands, wildflower meadows and willow and alder beds, each area connected by wooden walkways accessed by the Ecology Park Gatehouse, a low-profile green roof timber-built structure. Covered with green vegetation over a waterproof membrane, the roof not only provides excellent insulation for the gatehouse, it also creates a wonderful habitat for various species flora, fauna and insect life. A new £60,000 outdoor classroom has been planned to be erected adjacent to, and partly suspended above, a lake. Through the park's ongoing fundraising activities future plans also include the construction of a new ecology building and additional staffing to provide environmental wildlife education for children as well as adults. Surrounding the park is an outer boardwalk, open for twenty-four hours a day, freely accessible to members of the public out for a brisk walk or leisurely stroll.

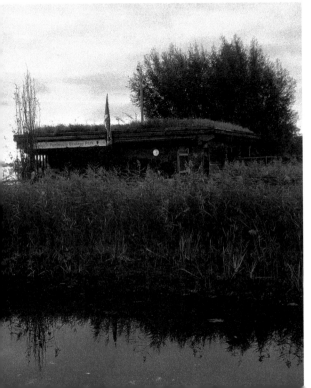

Ecology Park gatehouse and freshwater pool.

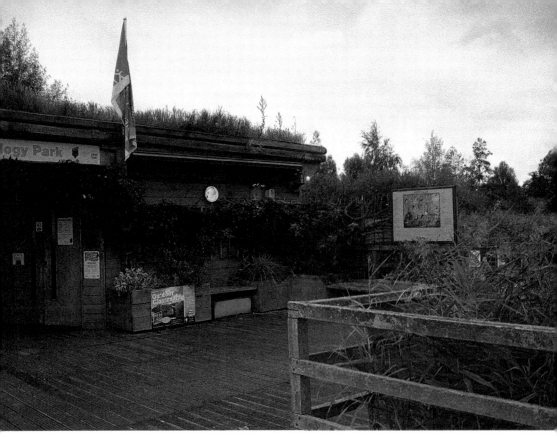

Above: Main entrance to Ecology Park, Olympian Way.

Right: Boardwalk leading from the gatehouse into 4 acres of freshwater habitat.

42. Peter Harrison Planetarium, Greenwich Park

Housed below a bronze cone weighing 55 tons, the Peter Harrison Planetarium, which opened in May 2007, was named after the foundation that provided funding to build the centrepiece of the Royal Observatory's 'Time and Space' project. The 120-seat underground digital laser planetarium, accessed by the Weller Astronomy Galleries, stages celestial sound and light shows, which at the time of opening was the only functioning planetarium in London. Designed by architects Allies and Morrison, the planetarium's external bronze housing was made up of seamless welded panels pre-weathered to give the appearance of age. Positioned on a plain granite terrace 50 metres east of the Prime Meridian, the cone encloses a steel- and concrete-built dome, on which planetarium light shows are projected on, suspended above the auditorium. The cone was designed tilted at an angle, one side pointing directly upwards towards the North Star, a vertical groove on the side marking the line of sight, the opposite side positioned at an angle of 51.5° north, corresponding to the latitude of Greenwich. Sliced across at a right angle parallel to the equator, the cone's polished sectional surface only ever reflects the sky of the northern hemisphere.

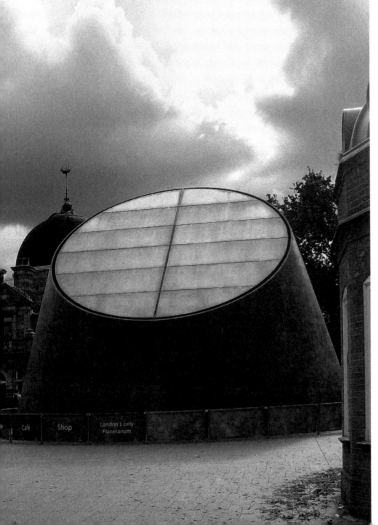

Planetarium bronze cone, Weller Astronomy Galleries, Greenwich Park.

43. Air Line Cable Car, East Parkside

Linking Greenwich Peninsula to the former East London Royal Docks, the Emirates Air Line cable car, designed by architects Wilkinson Eyre and built at an estimated cost of £60 million, began transporting passengers across the River Thames in June 2012. The thirty-four gondolas, each carrying a maximum of ten passengers, travel 1,100 metres across the river at a height of up to 90 metres on cables supported by three elegantly designed spiral pylons. The crossing, or flight as the journey is described, can take between five to ten minutes, depending on the time of day, as the gondolas travel faster during commuter rush hours. On each side of the river, at the end of the cable line, are stand-alone glazed pavilions, the upper storey containing a boarding platform that cantilevers out over the ground-level ticket office. The larger of the two pavilions, on the Greenwich side, includes a large gondola garage and service workshop, the electric motor driving the Air Line installed within the pavilion north of the river. Located at the Greenwich Pavilion, the Emirates Aviation Experience is a state-of-the-art interactive commercial airline travel exhibition, which includes four aircraft flight simulators where visitors can practice their taking off and landing skills. Travelling across the Thames by gondola offers passengers marvellous aerial views over the Thames below and a magnificent panoramic outlook across London. One passenger recording their trip inadvertently caught in the frame what appeared to be

Emirates Air Line Gondola Pavilion, Edmund Halley Way.

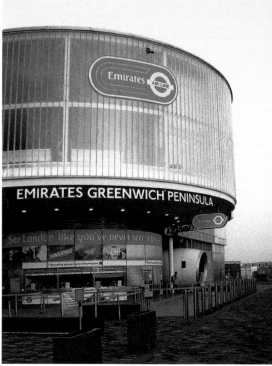

Above left: Air Line cable car pylons south and north of the Thames.

Above right: Emirates Air Line ticket office and exhibition centre.

a large creature breaking the surface of the river, leading to speculation it was the Thames equivalent of the Loch Ness Monster. The film sequence, posted online in March 2016, led to speculation the incident may well have been an early April Fool's Day hoax; however, in all probability the sighting was either a whale or a school of dolphin disturbing the water having accidentally swum up the Thames.

44. Meantime Brewery, Blackwall Lane

Greenwich has long associations with the brewing industry, from a time when the manor belonged to the Abbey of St Peter of Ghent. The first Greenwich brewers are believed to have been a thirteenth-century order of Flemish monks who travelled to the manor and established a small abbey, which included a brewery, in West Greenwich. Ever since this time a succession of Greenwich brewers produced various types of beers and ales for sale locally up until the mid-1900s, when large national breweries began buying up small independent brewers and taking over ownership of public houses. At the turn of the twenty-first century, Alastair Hook, university post graduate in brewing and bio chemistry, founded the Meantime Brewery and began brewing beer in a small unit on a Charlton industrial estate, producing a variety of historic beers from old brewing recipes. Within ten years Meantime Brewery had moved to a new state-of-the-art Moeschle brewery on Blackwall Lane, at a cost of £2 million, Moeschle referring to large stainless-steel tanks originally used for making wine. The brewery produced 25,000 hectolitres of

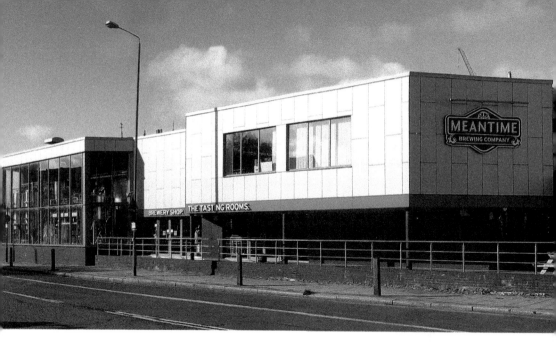

Above: Meantime
Brewing Co.,
Blackwall Lane.

Right: Brewery entrance
and yard.

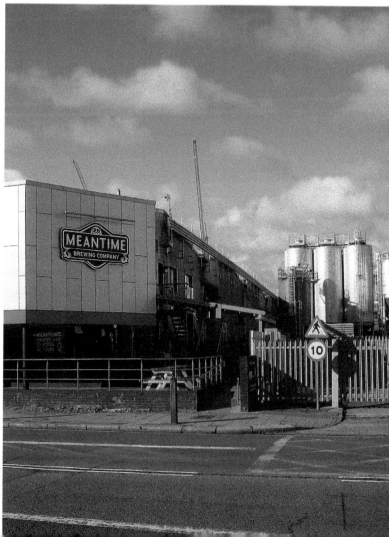

ales, lagers and speciality beers annually, with the cask and bottled beer distributed to public houses, supermarkets and off-licences. During the same year Meantime opened the Old Brewery, Bar and Restaurant within the original pensioners brewery building of Greenwich Hospital (the Old Royal Naval College) in close proximity to the site of the Greyfriars Abbey brewery. All of Meantime's beer is now brewed at the Blackwall Lane site, and the brewery is regarded as London's largest investment in craft beer brewing in over eighty years. The Meantime Brewery, which has a shop, licensed bar and restaurant at the front of the building, runs group brewery tours and tastings, where customers can sample a variety of the brewery's beers. After recently expanding the brewery premises, Meantime intends to increase production to 120,000 hectolitres a year, equivalent to 2.6 million gallons of beer, ale and lager brewed at the Greenwich brewery.

45. Cutty Sark Visitor Centre, Greenwich Church Street

The most famous tea clipper in the world, the Clyde-built *Cutty Sark*, which once sailed across all the seas and oceans of the world, is now a museum ship seemingly to be floating on a sea made of glass, the roof of the ship's controversial visitor centre. Designed by architects Grimshaw, the visitor centre was not well received by prominent heritage groups, the

Cutty Sark's enclosed glass visitor centre off Greenwich Church Street.

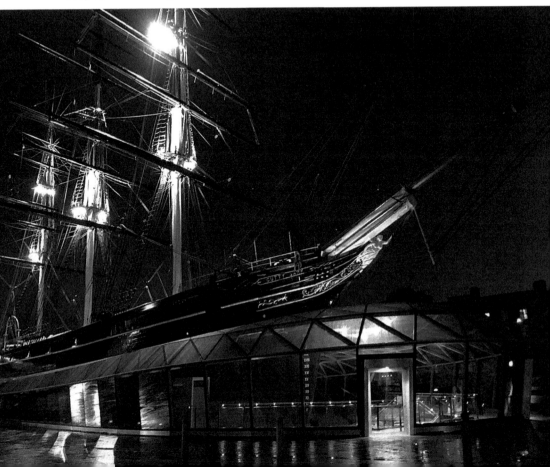

The clipper's copper-clad hull sheltered within the glass-panelled enclosure.

tinted-glass and metal-framed structure said to obscure the ship's distinctive flowing lines. The building, however, gave visitors easy access onto all decks of the clipper and allowed them to walk below the vessels vast copper clad hull. The enclosed space below the Cutty Sark, once the ship's opened dry dock, was transformed into an exhibition centre and display area for a collection of historic ships' figureheads. To the ship's stern is the visitor centre café serving various refreshments including the beverage the clipper became famed for carrying home from the Far East – tea. The nineteenth-century clipper had been saved for posterity when placed in the dry dock at Greenwich in 1954. Following restoration and a refit the clipper was officially opened as a nautical museum by Elizabeth II in 1957. After almost fifty years open to the public, the clipper was in need of major repairs and while undergoing refurbishment and renovation in 2007, a raging blaze aboard almost destroyed the hull of the historic seafaring monument. As a majority of the ship's superstructure and its masts and decking had already been removed for overhaul and storage, the fire did not cause as much damage as first feared. In 2015, the queen returned to reopen the clipper after completion of the £50-million restoration and building of the new innovative visitor centre. Since the *Cutty Sark*'s reopening, the clipper and the visitor centre has hosted over 200 events, from Rabbie Burns Night celebrations to wedding ceremonies, and annual visitor numbers increased from 140,000 to 350,000. Although the visitor centre received the Building Design Carbuncle Cup 2012, awarded to Britain's worst building, a year later the visitor centre was voted Royal Institute of British Architects Regional Award Winner 2013.

Visitor centre access tower to ship levels and undercroft.

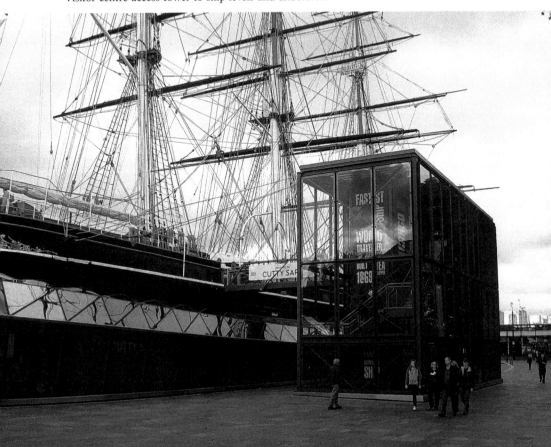

46. Ravensbourne College, Peninsula Square

When Ravensbourne College of Design and Communication outgrew its Chislehurst campus, rather than merge with another educational institution, architect Farshid Moussavi was commissioned to design an eye-catching modern college complex accommodating up to 1,400 students studying design and digital media. After planning had been approved to build the college at the new business centre on Greenwich Peninsula, close to the O2 Arena, work began on constructing the ultra-modern chevron-shaped building in 2008. Constructed in steel and concrete, the façade was clad in 28,000 mathematically patterned anodised aluminium tiles, inset with circular glazed windows to provide natural controlled light to each floor of the building. The external wall patterning, made up from tiles of three different shapes and colours, had originally been created for a Spanish building project that was cancelled. The distinctive design of the four-storey college interior, measuring a total floor space of just over 14,000 square metres, dispensed with classrooms, offices and corridors in favour of open-plan work spaces, atriums, studios, production and technology hubs, as well as several quiet areas, the layout intending to provide the best environment for students to study. The futuristic building, completed in the summer of 2010 at a cost

Ravensbourne College,
Peninsula Square.

Left: College innovative roundel window.

Below: Public commercial spaces on the college ground level.

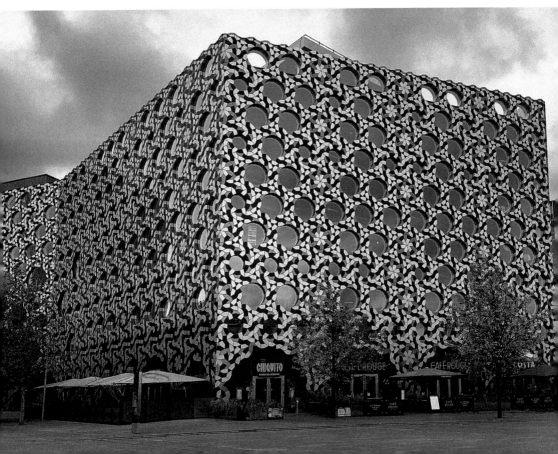

of £70 million, the funding secured through grants and loans, had been created to be low maintenance and BREEAM (Building Research Establishment Environmental Assessment Method) accredited, a qualification of environmental excellence. At the beginning of the academic year the students moved into the new college retitled simply Ravensbourne.On the building's ground floor, the large glazed arched fronted commercial spaces have been leased out to restaurants and a coffee bar for the use of both students and the public. In 2011, the new Ravensbourne campus won the British Construction Industry Award for London's most innovative higher education building.

47. Greenwich Yacht Club, Peartree Way

Founded by Thames Watermen and river workers at the Yacht Tavern, Crane Street, in 1908, Greenwich Yacht Club members held meetings at the historic riverside public house until moving premises to the *Iverna*, a former working Thames sailing barge, beached adjacent to site of the present clubhouse. After moving from the barge to a hut on Mudlarks Beach – mudlarks referring to London's poor, usually boys and girls who waded out in the mud at low tide to search for anything saleable, bits of metal, coal, rope and canvas – the club relocated to a small clubhouse at the end of Riverway, a lane leading from the Pilot public house to the Thames riverbank. When Greenwich Marsh was designated an

Greenwich Yacht Club and riverside flotsam and jetsam marine sculpture.

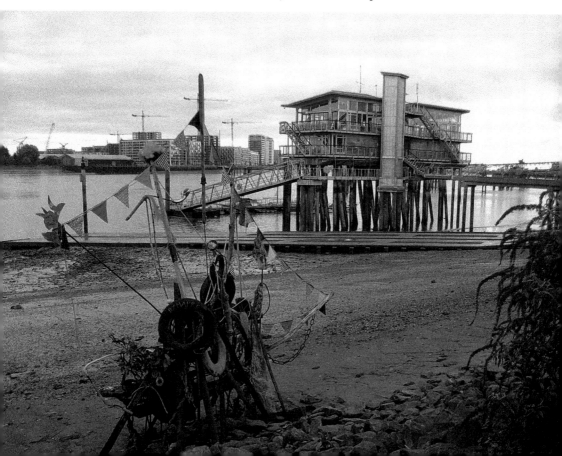

area of regeneration and the site of the old clubhouse was acquired for redevelopment by land developers English Partnerships, the Greenwich Yacht Club was provided with new premises at a cost of £3.5 million, built at the redundant Peartree Wharf. Designed by London architects Frankl and Luty Ltd, the two-storey clubhouse was erected on the concrete platform of a jetty supported by timber stilts, the only building erected in the Thames raised above the water by such a method. The clubhouse framework and walls were made of exposed steelwork and timber cladding, the floors constructed in natural pine, and the heavy-duty glazed windows framed with pine and aluminium. Accessed from land by way of a long supported pedestrian footbridge, the clubhouse can also be reached from the yacht club member's boat pontoon. The yacht club complex includes shore-based boatsheds, sail loft, woodwork and engineering workshops, a large open-air boatyard and a function room, formerly a temporary clubhouse used while the main clubhouse was being

Clubhouse erected on former jetty, Peartree Way.

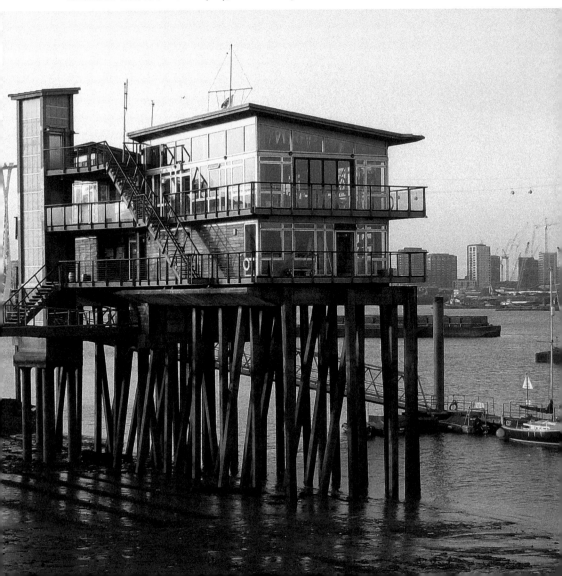

built. The function room overlooking the river is now hired out as a venue for corporate events, celebratory occasions and wedding receptions. Greenwich Yacht Club members organise races for various classes of yachts and dinghys, and hold regular club membership nights and festive events in the clubhouse bar throughout the year.

48. Greenwich University Library and Academic Centre, Stockwell Street

After Greenwich University moved into the Old Royal Naval College buildings a competition was launched in 2008 to design a library and academic centre to be built on a derelict site at Stockwell Street, West Greenwich. Although a design by Dublin-based architects Heneghan Peng won the contest, concerns were raised that the dynamic design did not complement the traditional styles of other notable Greenwich buildings, and the exterior required some subtle changes before construction could proceed. On completion in 2014, at a cost of £80 million, the four-storey building's frontage had been clad in limestone to match the classical buildings in close proximity to the new University Library, including St Alfege Church, the Old Royal Naval College and the National Maritime Museum. The interior, however, retained the original architectural design features – high ceilings, meshwork balustrades, a majestic zigzag-style steel staircase, rough cast concrete and steelwork – and exposed service ducts and trunking. From the highest point of the university building the roof stepped down in fourteen terraced gardens used for the study of algae and aquaponics. Along with

Greenwich University,
Stockwell Street.

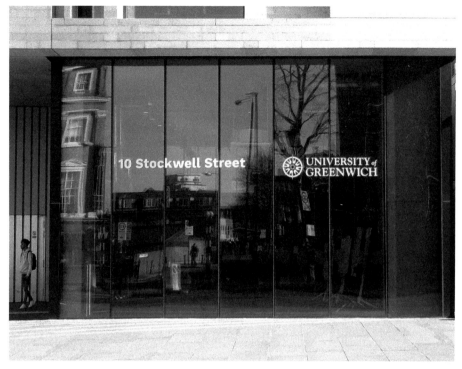

Main entrance leading to the university and public spaces.

a library, the building also housed departments of architecture and landscape along with digital arts and creative professions. The ground floor, accessed by students and the public, included a lecture theatre, exhibition areas, café, print shop and legal advice centre. In 2015, the Stockwell Street building won the Royal Institute of British Architects London Award for Architecture Excellence, and received the Royal Institute of British Architects National Award, the building recognised for making significant contributions to architecture.

49. Peninsula Spire, Peninsula Square

At the centre of the new business district of Greenwich Peninsula stands a 45-metre-high gleaming stainless steel mast, which although not classified a building, is worthy of inclusion as the Peninsula Spire, as it is known, is the tallest steel spire in Britain. The thirty-four ton triangular tapering mast, designed by London Architects Bar Gazetas and built by engineers WhitbyBird of London, was made in three sections before fitted and invisibly welded together by Swiss craftsmen Tuchschmid. Erected in 2006, the mast, acting as the key landmark of Peninsula Square, is positioned adjacent to a three-storey high blue coloured glass performance wall and digital display screen, the wall lit internally with colour changing LEDs, which reflect brilliantly off the spire's steel surface at night. The granite paved square on which the spire stands, the largest installation of natural stone paving in London, has been etched with passages of text and verses written by poet Mick Delap, recalling Greenwich history. Inset within the paving are several water geysers, designed by artist Mel Chantrey,

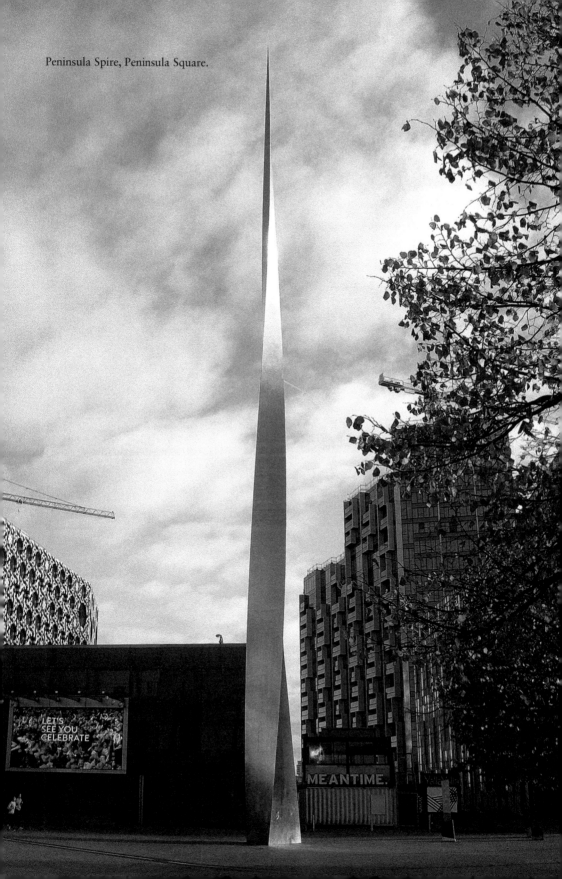

Peninsula Spire, Peninsula Square.

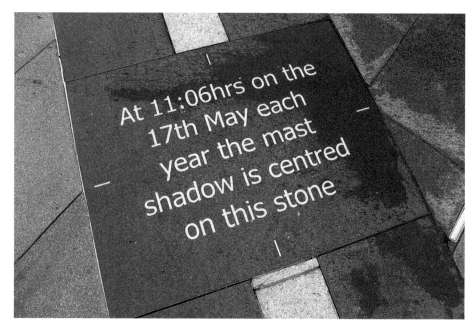

Stone text slab on a line of longitude east of Greenwich Meridian.

from where water calmly bubbles up in circles before shooting up in a single fountain some ten metres high, much to the delight of paddling children.

5c. Low Carbon District Energy Centre, Millennium Way

On Greenwich Peninsula, in sight of the nineteenth-century disused gasholder, under threat of demolition by developers, a twenty-first-century low carbon district energy centre, designed by C. F. Møller one of Scandinavia's leading architectural companies, was built to provide heat and energy for new properties erected across the Greenwich Peninsula. Run by Pinnacle Power, the energy centre's advanced boiler technology saves up to 20,000 tons of carbon annually while generating electricity and producing heat and hot water. On completion in 2017, the energy centre, recognised as Europe's largest heating network system, supplied buildings with power and heat through a series of subterranean insulated pipes. The rectangular energy building, situated next to the southbound Blackwall Tunnel exit road, is clad in black panels and on its southern side inset with long horizontal tinted windows. The energy complex comprises of a substation, gas governor house, interactive educational visitor centre, offices and a striking forty-nine metre high architectural flue stack, the Optic Cloak. Commissioned by developer Knight Dragon and designed by artist Conrad Shawcross, the flue stack's sculptured geometric surface was based on First World War dazzle camouflage. Made from hundreds of perforated triangular aluminium panels, the flue appears to change shape throughout the day as light from the sun and sky filters through and off the panels. At night the flue, illuminated from within by a composition of coloured lighting effects, can be seen from across a majority of the Greenwich Peninsula. During the next twenty years the energy centre will serve an estimated 25,000 residents of Greenwich.

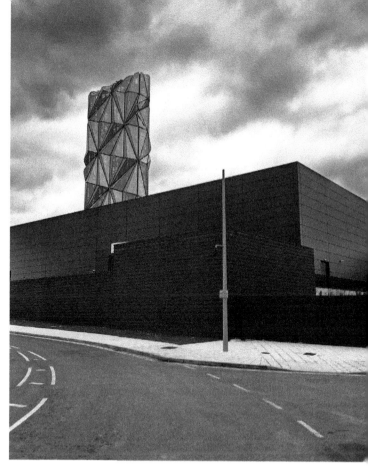

Right: Low Carbon District Energy Centre and Optic Cloak flue off Millennium Way.

Below left: The energy centre's administration area behind vast glass-panelled windows.

Below Right: Energy centres old and new, with Greenwich's iconic, historic gasholder in the background.

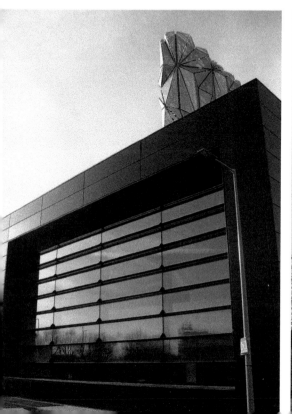

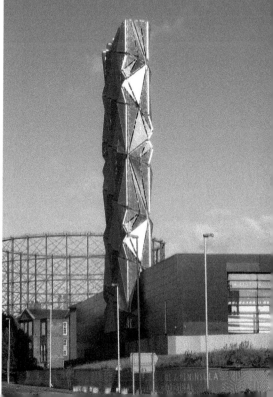

Acknowledgements

I would like to thank all those who have contributed to this publication, providing information and giving permission to take photographs. If for any reason I have not accredited people or organisations as necessary, I should like to apologise for any oversight. I should also like to express my thanks to the following list of organisations without whose help I would not have been able to produce this book: The Greenwich Heritage Centre, Caird Library & Archive –w National Maritime Museum, The British Library, The Greenwich Industrial Heritage Society, The Cutty Sark Trust, The Old Royal Naval College, Royal Parks, The London Encyclopaedia, British History Online and Low Carbon District Energy Centre.